IMAGES
of America

MOLALLA

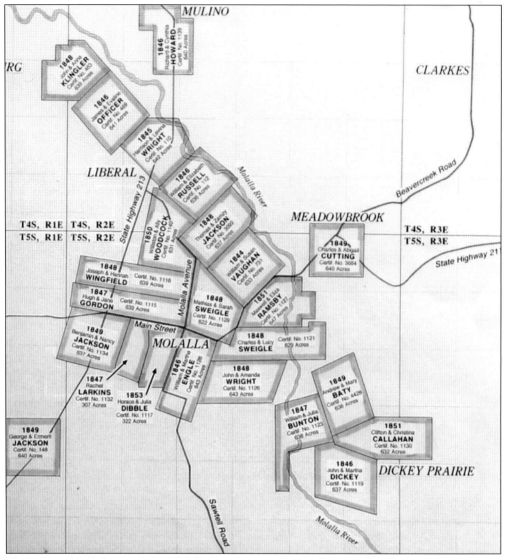

The earliest land claims in the Molalla area were permanently settled by Oregon pioneers prior to 1852. Shown here are several land claimants' names, the year settled, the donation land claim certificate number, and total acreage. This map was drawn from cadastral survey records, donation land claim records, publications from the Bureau of Land Management, and land claim information from the Genealogical Forum of Oregon. (Map by Champ Clark Vaughan, 2001.)

ON THE COVER: The Milster/Dibble family enjoys a picnic at Wilhoit Mineral Springs around 1894. Located outside of Molalla, Wilhoit Springs was a popular resort within a wooded park that offered soda and sulfur spring water as a restorative health drink. The springs became well known in 1884 after a German study proclaimed the waters similar to famous European spas. (MAHS.)

IMAGES
of America
MOLALLA

Judith Sanders Chapman and
Lois E. Helvey Ray

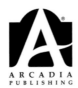

ARCADIA
PUBLISHING

Published by Arcadia Publishing
Charleston SC, Chicago IL, Portsmouth NH, San Francisco CA

Printed in the United States of America

Library of Congress Catalog Card Number: 2007935831

For all general information contact Arcadia Publishing at:
Telephone 843-853-2070
Fax 843-853-0044
E-mail sales@arcadiapublishing.com
For customer service and orders:
Toll-Free 1-888-313-2665

Visit us on the Internet at www.arcadiapublishing.com

*To the Molalla pioneers who left behind their stories and images,
and to our families for supporting us in this endeavor*

CONTENTS

ACKNOWLEDGMENTS

The authors are indebted to the following organizations for providing photographs of old Molalla: Molalla Area Historical Society (MAHS), Clackamas County Historical Society, Oregon Historical Society, University of Oregon Special Collections, Salem Public Library, Oregon State Archives, Molalla Public Library, the *Molalla Pioneer*, and Weyerhaeuser. Special thanks go to Champ and Maria Vaughan for assistance, support, and dedication to the project.

We are indebted to the following people who lent us their personal images of the past and assisted us in discovering the story of Molalla: John Chelson, Dianne Jeli, Marie Wells, Cecil Werner, Delores Williams, Reina Holman, Iris Shaver Coulson, Carl and Orville Cline, Howard and Ruth Heinz, Judy Gregory Kromer, Arline Gregory, Jude Kappler Strader, Janine Kester, Doris Rosenow, Susie Dickey Davies, Dave Dickey, Shirley Fourier, Judy Price, Merle and Betty Tomminger, Don Olsen, Allan DeFabio, Lois Lay, Wally and Judy Aho, JoAnn Wiegele Olsen, Linda Fries Fuellas, Marilyn Sawtell Behrends, Bland and Marquitta Foglesong, Blanche Kober, Isabel Williams, Nora DeFrates, Irene Helvey Emmert, Bruce C. Helvey, Mike Cole and Bruce Thiel of Avison Group, Ellen Thronson, Mya Oblack, Hannah Schink, Odeane Thelander, Ralph Piuser, Ruth Phillips, and Marlene Seethoff. For technical and research support, we could not have done without Clark L. Helvey.

We also thank Mary Castle at the Dickey Prairie Weyerhaeuser office for her assistance. Thank you, Stephanie Shaver Stogner, for aiding with photocopying at LBJ Printing in Molalla. Last but definitely not least, we are very grateful for Liese Chapman's efforts involving image organization.

INTRODUCTION

Molalla is situated in southwest Clackamas County in a wonderfully scenic area that offers a rural lifestyle greatly appreciated by residents and recreationalists alike. Its outstanding natural features, small-town atmosphere, and close proximity to the Portland metropolitan area, the Cascade Mountains, and the Oregon coast contribute to Molalla's livability. It is the ideal Western town. Since the earliest days of settlement, economic incentives from agriculture, livestock, crop production, and lumber have dominated the lives of Molalla's residents. Local people continue to thrive on many of the virtues that characterized their pioneer fathers. Indeed, many descendants of the earliest pioneer stock reside in the area today.

Historically the Molalla Prairie was a beautiful oak savannah set against the thickly forested foothills of the Cascade Mountains. The region was inhabited by the Molala Indians, whose trails and settlements marked their territory. Reportedly the first European American to pass a favorable eye over the area was William Russell, who came in late 1843 to the banks of the Molalla River, but was reportedly driven off by the Native Americans. He returned later to settle a government land claim. William Vaughan, who later became known as the "Sage of Molalla," hoisted his wagon up over the bluff at Oregon City and traveled south through the woods and fields to the Molalla Prairie in early 1844. He became the first permanent settler on a government land claim. Soon other settlers followed, lured by the fertile soils, ample water, and rich grasses of the Willamette Valley. Many of the first groups of pioneers who came over the Oregon Trail settled in the Molalla area.

Clackamas County was one of four original districts created in 1843 by the Provisional legislature, a governing body in the early Oregon Country that acted until legal authority was extended from the United States. Land claim acts had been passed to make it possible for married couples to file on free land comprising 640-acre parcels. Claimants were required to build a residence and cultivate a portion of the claim to secure a land patent. The law gave 320 acres to a man and 640 to a man and wife—creating one of the few instances in which a woman could actually own land.

A donation land claim of 640 acres was taken up at each of the four corners. William Engle claimed the southeast corner, William Larkins the southwest corner, Hugh Gordon the northwest corner, and William Barlow, the northeast corner, which was later purchased by Charles Sweigle. In 1845, when William Engle arrived, he built the first log cabin in the area. William Barlow came in 1847 and started a wheat field on his claim while building a large barn from locally sawn lumber. Hugh Gordon looked around the Willamette Valley for the best land to claim, finally settling on the Molalla Prairie. When William Larkins arrived with his family in 1847, they spent the first night under a giant oak tree in the middle of a trail (present-day Highway 211 west of Molalla). Rachel Larkins received title to this land claim when her husband died. She later sold the claim to Horace Dibble, who completed his saltbox-style house in 1859, the year Oregon became a state. The house still stands as part of the Molalla Area Historical Society Museum complex.

Other early settlers who took advantage of free land under the government were the Cutting, Dart, Dickey, Woodcock, Baty, and Davis families, several having chosen the fertile soils southeast

of Molalla on Dickey Prairie. As subsistence farmers, these early settlers raised livestock and grew wheat and hay. Several Molala Indians were still living in the Dickey Prairie area at this time, but most had been decimated by disease or relocated to reservations by the mid-1850s. The former Native American trails later became Main Street and Molalla Avenue where they intersected at Four Corners, the first named settlement. The change in name to Molalla resulted from the Molala Indians (Molala is the preferred spelling for the local tribe). The derivation is unknown, but the word has been described as a variant in the native people's language for "the land of elk and berries" or "the grass country."

Oregon became a United States territory in 1848, which encouraged settlement, especially after passage of the Donation Land Act in 1850. Many of the new settlers were anti-Republican Secessionists from the South, causing Molalla to become one of the few Secessionist precincts in Clackamas County. The 1850 census shows 19 heads of households in the Upper Molalla Precinct. They included members of the Wright, Engle, Reese, Cline, Vaughan, Jackson, Russell, Riggs, Callahan, Officer, Klinger, Woodcock, Sweigle, Wingfield, Gordon, and Larkins families.

In 1853, the area was sparsely settled, but by the late 1850s, Molalla had the beginnings of an agricultural center with the establishment of the first store building. Through the 1860s and 1870s, the town developed slowly but saw gains in agricultural production. J. V. Harless, a Molalla farmer who arrived in 1877, owned the first steam traction engine in the area. The following is an account in the *Molalla Pioneer* from years ago:

> Mr. Harless told me that every time the engine blew off steam the farmers would drop their pitchforks and run for their lives. For which they could hardly be blamed, because those old engines had a habit of blowing up and scattering pieces of metal all over the map. When the Harless family first came to Molalla there were just two stores and one blacksmith shop, and all the grain raised in that part of the county was hauled to Oregon City for sale or shipment.

The 1870s brought the establishment of the Methodist and Christian churches, along with a new school building, to Molalla. With the 1880s came a proliferation of gold claims along the upper Molalla River and several mining operations. Much later, a coal mine opened. These increases in mining activity added more population to the town. Wilhoit Mineral Springs, a popular destination established southwest of town in the 1880s, became a famous resort until it fell into disrepair; today no recreational buildings remain at this Clackamas County Park. One can still stock up on the curative waters, however, declared in the Springs' heyday as comparable to famous German spas. Molalla had a rowdy reputation at the close of the 1800s—others said it was simply the liveliest spot in the country.

As Molalla grew into a Western frontier city, an increasing number of people moved into the area during the early years of the 1900s. Molalla was always somewhat isolated and nestled against the foothills; hence it formed an "indefinable mystique," according to some, that was eventually "cracked" by outsiders. Large family groups had established themselves, intermarried, and worked together on farms. As a consequence, those with pioneer forebears became the town leaders and started the earliest businesses. Commercial growth and development and population increases in turn brought changes in transportation and industry during the second two decades of the 20th century. Lining the streets were a milliner, meat shop, furniture and notions store, telephone office, paint and oil store, cobbler, musical instrument shop, barber, and fruit and confectioner's shop. Also in existence were a hotel, the Lyric Theatre, a billiard hall that sold cigars, and a restaurant and drugstore. A brick and tile industry was located outside of town.

On September 19, 1913, the first train pulled into Molalla, signifying the prospect of increased commerce for shipping agricultural products by train. A town celebration marked the event, and to add to the excitement, a small Western rodeo show was staged, with prizes for bull riding and other bronc-busting activities. As a result of the town's new pride, businesses were built. Now the town could boast a bank (the first fireproof construction, still standing on the southeast corner of

Main Street and Molalla Avenue), two churches, a weekly newspaper, two auto garages, several sawmills, and various stores. Shops offered hardware, imports, drugs, automobiles, notions, paint, furniture, general merchandise, feed, warehousing, meats, and lumber. Two physicians and one dentist served the town.

The Molalla Buckeroo became the third rodeo established in Oregon when Wild West events and rodeo contests were sponsored at the large city celebration in 1913. The first organized rodeo event was the 1923 Round-Up presented by the Molalla American Legion Post 93. Mayor Ralph L. Holman delivered an address while concessions and a merry-go-round were provided for the children. The Canby and Molalla baseball teams played a game in Molalla the morning before the Round-Up started. Everett Wilson, manager of the show, brought a large number of Native Americans from the Dalles to participate in the races and stunts. The 1926 Round-Up was used in the production of a five-reel feature motion picture by Fleming Productions of Beaverton. Molalla slowly exhibited growth while retaining its Western flavor and never became a big town. By the 1920s, the *Molalla Pioneer* editor Gordon Taylor had written the following:

> Molalla has developed from the "Four Corners" with mud streets, open ditches, and one little narrow sidewalk, lighted by kerosene lamp, with a four room school poorly lighted and out of date, to a modern little city. We now have paved streets, cement sidewalks, beautiful homes, and electric service furnished by the P. E. P. Company. We have two railroads, the W. V. S. Electric, and the Southern Pacific short-line steam train from Canby. The road to Portland is paved except three miles; that will be paved next year. There is a gravity water system, owned by the city, which provides Molalla with an abundance of pure, mountain water. This summer we will build a new union high school building for 18 school districts. The school will have a Smith-Hughes agricultural and vocational training department, the only one in Clackamas County. The Eastern and Western Lumber Company is building one of the very best logging roads in the state. They will begin logging next year in their own stand of timber, which should last for 20 years. We have a brick and tile factory, which has a mine of exceptionally good quality clay.

Though no longer standing, Molalla's pride of architecture and source of community identity was the 1925–1926 brick Renaissance-style high school building. The school was described as a beautifully designed structure with sloping, landscaped lawns that added greatly to the appearance of the town. It had a large auditorium, a gymnasium, home economics rooms, a well-equipped commercial department, and an athletic field.

Large deposits of clay inhabited the outskirts of town. By the middle of the 20th century, raw clay was being shipped to manufacturing plants for the production of china, pottery, terra cotta tile, brick, and cosmetic clay.

In the 1930s, Molalla continued as a center for agriculture. New technology with gas- and diesel-powered equipment was the wave of the future, and the last of the Molalla Prairie was turned under. One of the most interesting farms was a large teasel ranch owned and operated by George H. Gregory from a business started by the Sawtell family on Teasel Creek in 1860. The teasel was used in textile mills to raise the nap on fabric. In Molalla, the growing, cutting, and shipping of dried teasel heads used in machines to comb the fabric brought employment to many. Other highly specialized farms were in production for fruits, grains, nuts, berries (especially strawberries), dairying, swine, rabbits, foxes, cattle, sheep, and poultry.

Community members were highly active in lodges such as the Grange, Masons, Odd Fellows, Modern Woodmen, Artisans, Rebekahs, Eastern Star, and Royal Neighbors. Civic pride was represented by the Molalla Women's Club, which presented the park on Molalla Avenue to the city and spent countless hours formulating ways to improve the area while continually adding books to the library. Businessmen and others in the Molalla Commercial Club lent their support to all business enterprises and civic undertakings. The Molalla Fire Department, for many years consisting of volunteers, promoted the annual Buckeroo each July, which brought fame to the city

for its Wild West events, the entire proceeds of which were donated to civic enterprises. There were music organizations, social clubs, equestrian clubs, and many other events for the enjoyment of Molalla residents. Several auto parks and resorts were located on the Molalla River, and trapping and hunting occurred in the nearby mountains. Fishing was one of the more popular activities on the Molalla River and other nearby streams.

A large lumbering district extended far into the Cascade Mountains to the south and east of Molalla by the 1940s, when lumber had become Molalla's principal industry. The big timber and lumber companies moved in. The Eastern and Western Lumber Company cut the timbered sections southeast of Molalla and set up logging camps. This firm was followed by the Ostrander Timber Company and later Crown Zellerbach. Local mills such as A. F. Lowes Lumber Company, Avison Lumber Mills, and Kappler Lumber Company soon dominated the industry. In 1944, a logging road was built leading to a log dump at Canby.

One

FIRST INHABITANTS
THE MOLALA INDIANS

Settlers arriving in the South Molalla region in the early 1840s entered the territory of the Molala Indians. The Molalas were a little-known group of indigenous Native Americans whose history is shrouded in mystery. Anthropologists suspect the Molalas settled this region after being pushed west by rival bands from the Oregon interior, but this theory has never been proven.

A band of Molalas living near the present city of Molalla were referred to as the Mukanti band of the Northern Molala, a culturally distinct subgroup of a larger nation. They shared linguistic traits with other Northern Molala bands in the region. According to an article titled "Molala" by anthropologists Henry B. Zenk and Bruce Rigsby printed by the Smithsonian Institution, the Molalas lived in rectangular, semi-subterranean houses with gable roofs in winter that were made comfortable with mats and hides and a fire pit for cooking and warmth. They ate food that had been gathered and dried during the milder months. In summer, they moved about and slept in temporary shelters made from log poles covered with woven grass mats.

The people subsisted by hunting, fishing, and gathering their food from local and distant foraging areas on a seasonal basis. Salmon, steelhead, and trout were caught in nearby rivers and streams or traded from neighboring groups on the Willamette and Columbia Rivers. Molala societal wealth was exhibited by the type and amount of material items owned, including horses, blankets, beads, shells, and ceremonial objects. Ceremonies, feasts, games, and dances were important to their society.

The Molalas' way of life was disrupted by the coming of the settlers. Many went to live on the Grand Ronde, Siletz, and Warm Springs Reservations, as decreed by an 1851 treaty, but several Molalas returned to Dickey Prairie in South Molalla. Artifacts attributed to the Molalas can still be seen today. Baskets and beaded moccasins are displayed at the McLoughlin House National Historic Site in Oregon City; the Thomas Burke Memorial Washington State Museum in Seattle; the Whatcom Museum of History and Art in Bellingham, Washington; the British Museum in London, England; and local private collections.

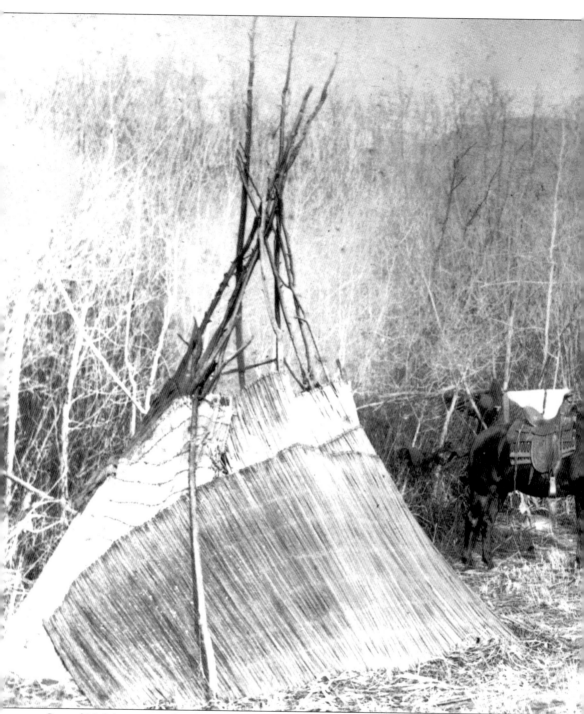

Several Molalas remained in the Dickey Prairie area, southeast of Molalla, after treaty negotiations in 1850 identified land east of the Molalla River as exclusively tribal. The Molala Indians had tried to reserve portions of their traditional territory through the Willamette Valley Treaty Commission in 1851, but the U.S. Senate never ratified the treaty. The superintendent of Indian Affairs noted 60 Molala men, 40 women, and 23 children living in the Molalla area at that time. Many were

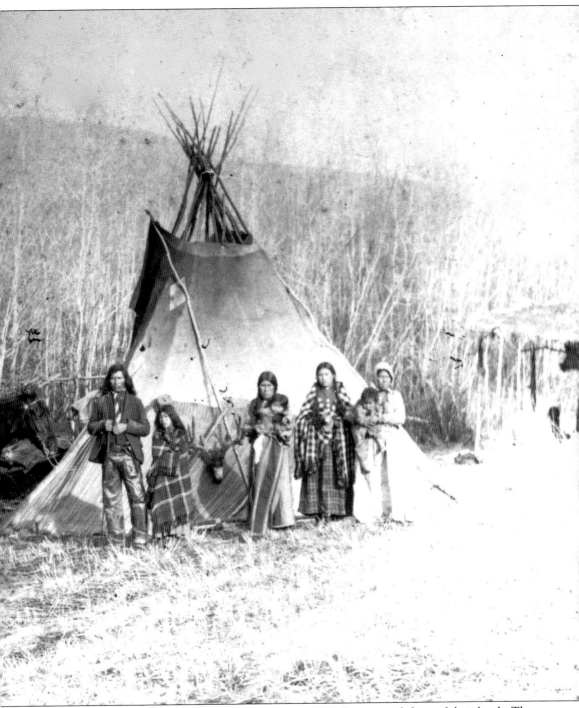

removed to reservations when a subsequent treaty in 1855 dispossessed them of their lands. The date and exact location (probably Dickey Prairie) of this rare view have not been identified, but records say it was taken by Silverton photographer William L. Jones, who worked as a traveling photographer after 1880. The image was provided by Tanner Baty in the 1970s. (MAHS.)

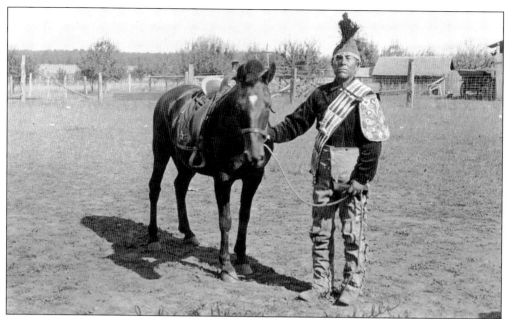

Henry Yelkes wears several items of traditional garb during a 1913 town celebration in which he led the parade and served as the guest of honor. He died three days later and was buried on Dickey Prairie next to his first wife and father. This photograph was taken by the Drake brothers, who purchased the Silverton studio from William L. Jones in 1904. (MAHS.)

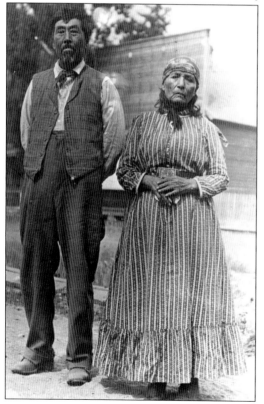

Henry Yelkes is shown with a native Molala woman thought to be his mother-in-law, Eliza Siam, born in 1840. Her husband was the medicine man Beaver Trapper, and their daughter was Nellie, Henry's wife from about 1880 to 1891. Eliza lived in a cabin at Henry's place after her husband died in 1893. By then Nellie had left Henry. (MAHS.)

In these two photographs, Jim Barlow (left in both images) is pictured with Henry Yelkes (right) and probably Eliza Siam (below), who was living in a cabin on Henry's property about 1912 or 1913. Around 1880, Henry brought home a young wife, Nellie, causing distress for his first wife, Kathryn. Kathryn, who may have been from the Klickitat tribe, was known for her expertly made gloves and moccasins fashioned from deer hides. Henry himself is listed as a glove maker in the 1910 census, using deer hides he tanned himself. Henry's first wife was so despondent over the appearance of Nellie that she reportedly dressed in her best bead-decorated clothing, put on necklaces of elk teeth, bells, and beads, and then went to the bank of Dickey Creek and hanged herself. (John Chelson.)

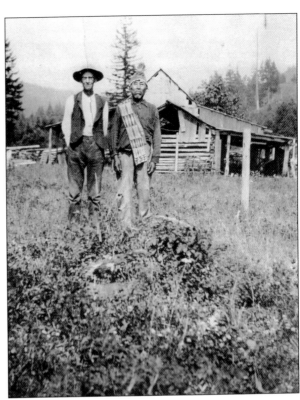

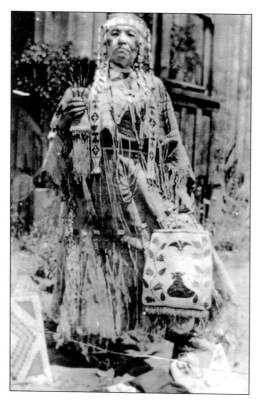

Kate Chantal, reportedly a daughter of Chief Henry Yelkes's sister, but probably the half-sister of Henry Yelkes, was born in the Molalla hills about 1840. In 1894, she married her fourth and last husband, Louis Chantal (Chintelle), at Grand Ronde. Kate served as an informant to ethnologist Philip Drucker and anthropologist Melville Jacobs during the late 1920s and early 1930s. She died in 1938. (MAHS.)

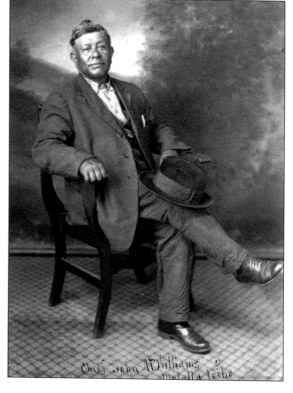

John M. Williams was the son of Kate Chantal and her second husband, a Hispanic man named Renaldo Matches. John, originally named Mattias, was born in 1868. John and his wife, Calousa (Davenport), had one son, whose name was either Matthew or Andrew Williams, in 1897 and a daughter, Cecelia, in 1892. (Clackamas County Historical Society.)

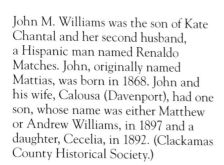

Born to Henry Yelkes in 1886, Frederick Yelkes was the last known speaker of the Molala language. This photograph may have been taken in 1937, when he led the parade at the annual Molalla Buckeroo celebration. He is shown on King, a horse bred by the Sawtell family of Molalla. (Marilyn Sawtell Behrends.)

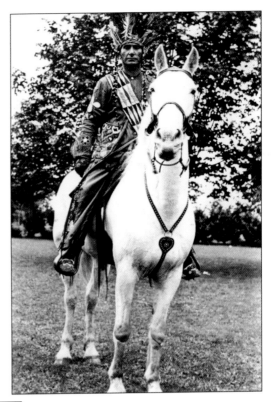

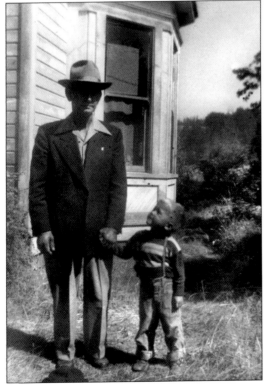

Frederick Yelkes (left) is seen with Dave Dickey at Ivor Davies's family home on Dickey Prairie around 1955. Dickey Prairie was named for Dave's ancestors, who settled near a Native American encampment in the 1840s. (Susanna Davies, Dave Dickey.)

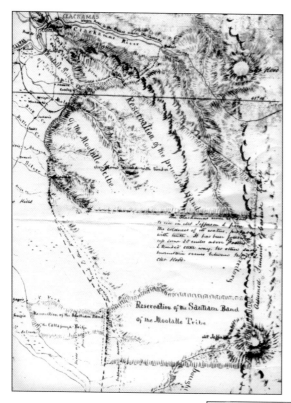

The "Reservation of the principal band of the Moolalle Tribe" is highlighted on this section of an 1851 map made during treaty negotiations that were never ratified. While some of this map is based on actual river surveys, most of the streams and marked locations are approximations. (National Archives and Records Administration.)

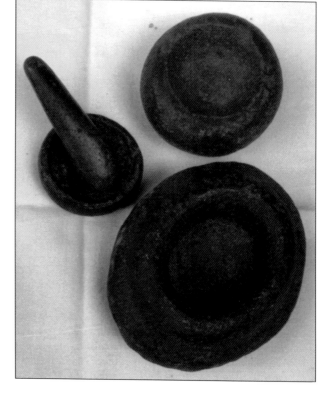

These stone bowls are in possession of Dickey family members whose ancestors were friendly with the Molala Indians on Dickey Prairie. Many artifacts found years ago in the Molalla area are attributed to the Molalas and reside in private collections. (Artifacts Dave Dickey; photograph Lois E. Ray.)

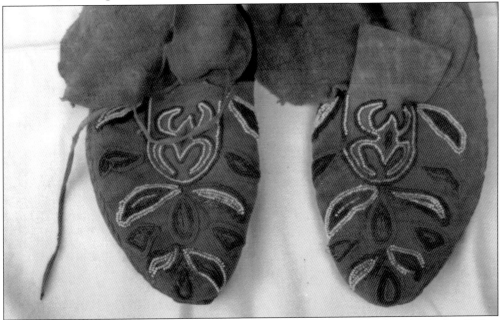

The following is a transcription of the handwritten field notes shown at the top of the page:

mus hut —

Bone & flint knives used to butcher deer. Cut down belly (chin to tail), inside legs — easy skin when warm — only back hard to skin. ♂ did; men butchered too. ♂,♀ both packed in — ♀ cut in strips to dry. Bear killed — cooked in earth-oven. No true bear rites. Beaver snared somehow, eaten. tá:min — rabbit — baby-blankets made of hide. Shot w. arrows, trapp'd. ♀ sometimes killed w. clubs. Wildcat, coon, coyote — Trapped. Coyote's howl sometimes indicated death.) Hides used.

Ducks, geese, grouse eaten — shot. Gathered eggs (ducks, geese, etc.) ate. Trouts, suckers eaten. Some kind people eat yellowjacket "eggs" — Molall. didn't. No wild honey-bees. Tanning — soaked — scraped. Elk ribs used — hell each end the drawknife. Brains & clay — salmon or eel-grease rubbed, with sticks, stone, smoke. 2 hides sewed to make one robe. Mostly ♀ job, — some men help. Dress — ♀ loose belted buckskin dress. (short). leggings (to knees — moccasins fan — (ičá xɔnʔ an häŋ eagle f. fan /?))

Dr. Philip Drucker (1911–1982), assistant curator for the U.S. National Museum and ethnologist and anthropologist for the Bureau of American Ethnology, prepared these notes in 1934 using information from Kate Chantal. The field notes depict Molala culture through drawings, language, descriptions of dress, and items used in everyday life. (MS 4516, Phillip Drucker Papers, Box 15, Coos Notebook, Volume 1, Molalla, 1934, National Anthropological Archives, Smithsonian Institution, Washington, D.C.)

This pair of moccasins belonged to Kathryn, the first wife of Henry Yelkes, when she died on Dickey Prairie in 1880. The moccasins sport orange, green, and white beads and are trimmed with black velvet cloth. Other items attributed to Kathryn are a jingle-bell necklace and a string of blue glass beads from the Hudson's Bay Company. (Moccasins Dave Dickey; photograph Lois E. Ray.)

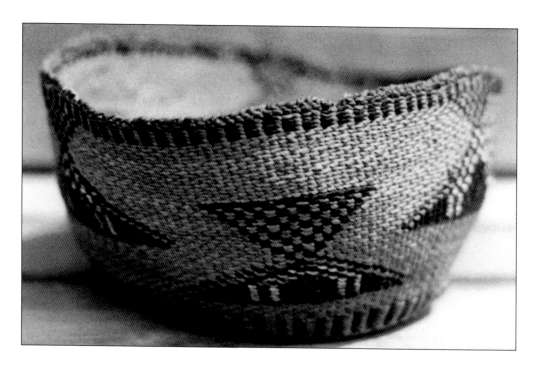

These two baskets were made by Molala Indians and donated to the Molalla Area Historical Society by the Dickey family. The basket above is about 12 inches in height, while the one below is about 8 inches. Both are on display in the Ivor Davies Hall at the Molalla Area Historical Society Museum in Molalla (the late Ivor Davies attended Henry's funeral in 1913 at the Indian Burial Ground on Dickey Prairie). Next to the baskets are large exhibits of stone tools and projectile points, many collected from the Dickey Prairie area. Several traditional items are attributed to Kate Chantal such as a doll, a beadwork bag, and a pair of moccasins at the McLoughlin House in Oregon City. (Lois E. Ray.)

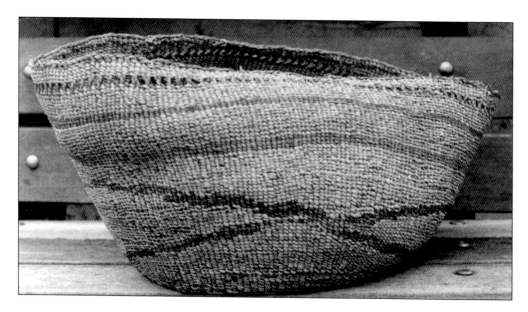

Two

FARMING AND RANCHING THE MOLALLA PRAIRIE

An 1845 description of the Molalla settlement portrayed it as a beautiful prairie dotted with groves of ancient Douglas fir. The forested foothills contained fir, oak, cedar, maple, alder, dogwood, and vine maple. The grassy prairies and fertile river-bottom soils attracted farming families to the area. These prairies may have been created by the native Molala people in order to facilitate hunting practices. Molalla was thus founded and later prospered as an agricultural community. The pioneer settlers who came over the Oregon Trail to reach the Willamette Valley were farmers from the Midwest seeking new land to till. The fertile, grassy prairies and well-drained bottomland near the Molalla River offered many advantages to the farmer and stock grazer. Most early settlers grew wheat to use as a medium of exchange and to satisfy land claim laws. William Barlow was contracted in 1856 for an order of 1,000 bushels of oats. The oats were standing in his field in the shock until it came time to harvest. He received $750 for the order. Prior to the establishment of the first sawmill around 1847, log and hand-hewn frame houses and barns with hand-split shake roofs were common on early farms.

Many early families operated subsistence farms by providing much of their own food through farming and raising livestock. A typical farmer raised cattle, hogs, horses, sheep, and chickens. Food was smoked, dried, preserved, or stored in cellars for the winter months. Farmers usually bought expensive threshing machines as a cooperative with neighbors and helped one another at harvest time. Homesteaders in the upper Molalla River area ran cattle until the timber companies moved in. Later, large-scale farms, nurseries, berries, orchards, dairies, stock farms, cereal crops, turkey farms, and cattle ranches dominated the economy. Molalla became the only community in the West to grow teasel for commercial purposes. By the mid-1900s, grains and hay constituted the larger portion of crops, along with alfalfa. Locally grown fruits were canned and sold under the Molalla Brand name. Molalla was also known for its cured bacon, sugar-cured hams, and smoked cuts of meat at the local meat shop.

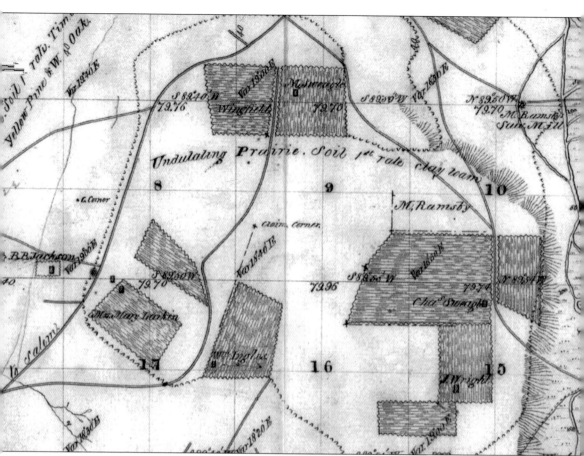

This 1852 cadastral survey map reveals the first land claims and wheat fields in the Molalla area. The names shown are Larkin (although it should read Larkins), Engle, Wingfield, Sweigle, Ramsby, Jackson, and Wright. Ramsby's sawmill is visible in the upper right corner. At the center is the "Claim Corner," where the four claims met to form the Four Corners that became Molalla's first town name. The Four Corners also served as the crossroads of two Native American trails that later became Main Street and Molalla Avenue. House locations are shown at several of the cultivated fields. The Molalla Prairie is outlined, and the soil is described as first rate. The Molalla River is on the right, and Highway 213 is on the left, listed as the road from Oregon City to Salem. (Bureau of Land Management.)

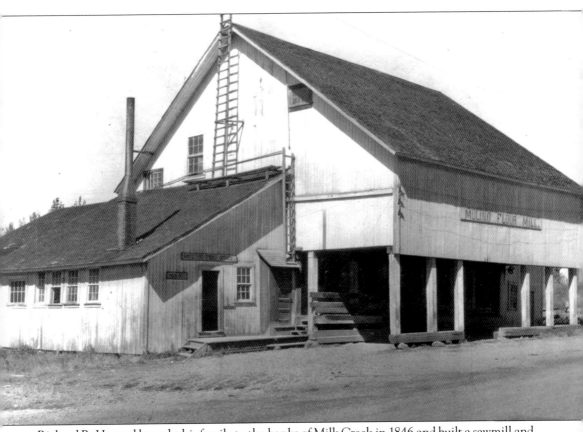

Richard R. Howard brought his family to the banks of Milk Creek in 1846 and built a sawmill and small cabin for his wife and nine children in 1848. He added a gristmill in 1851, shown in this 1938 photograph. The mill remains standing in Mulino, just north of Molalla. The mill stones, or burrs, and the bolting cloth for the gristmill were purchased in New York City and then sent around Cape Horn, arriving a year after they were ordered. Pack trains headed to the gold mines in Northern California and southern Oregon loaded with flour at the mill. In 1890, the mill was converted to a full roller process with three double-sets of rollers, allowing for 60 barrels of flour per day through two turbine wheels. The facility, which became known as the Mulino Flour Mill, was converted to electric power in the 1930s. (MAHS.)

Gabriel Trullinger started the Union Mills complex in 1854 as one of the earliest sawmills in the area, and the operation has remained in the family ever since. Trullinger and his wife, Sarah Glover, had settled the land claim along the banks of Milk Creek, just outside present Molalla, in 1852. He established a flour mill in 1877 to produce white flour, bran, and other grain products on steel rollers. A woolen mill was added in 1878. All three mills ran by waterpower from Milk Creek during the early years. The Trullingers also had a hop yard, and upstream was a water-powered furniture factory. Today the main Trullinger mill building and the farmhouse still stand. (Judith Chapman.)

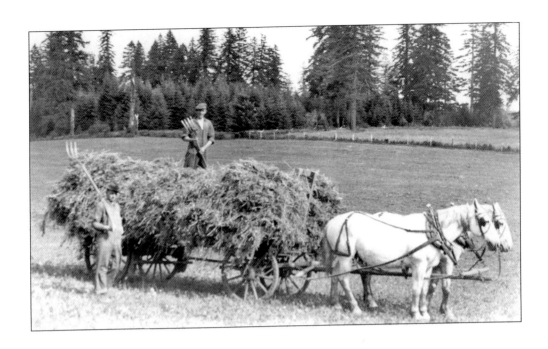

Farming was the traditional occupation for early settlers in Molalla. Once a house and barn were constructed, the farmer planted a garden, fruit trees, and berries; typically bought a hog, chickens, and sheep; and planted wheat, oats, and corn. Workhorses were the main source of power. After the grass was cut, it was left for a day or two to wilt and then turned to dry before being raked into rows for gathering. Farmers pitched hay onto horse carts (above) using long-handled pitchforks and then transported the crop to the barn. Haystacks had sloping sides to prevent rain from entering and rotting the hay. Below, the Holmans farm land they purchased from the Cutting Donation Land Claim in 1880. (Above MAHS; below Reina Holman.)

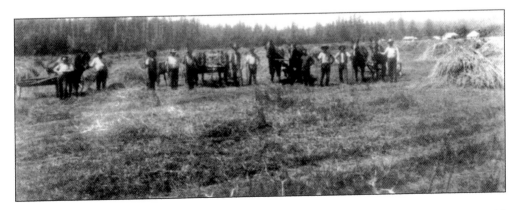

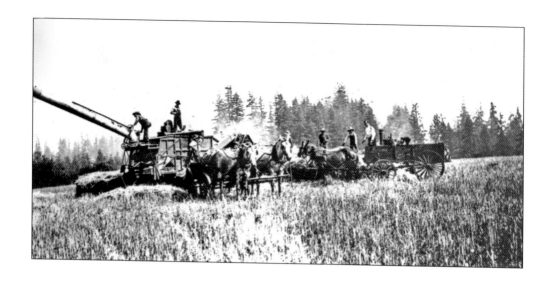

In the early days, a farmer usually cut his grain with a scythe and then cradled and hand-bound the bundles. The straw was often hand-flailed on a barn floor or trod on by horses in order to loosen the grain. Jacob Robbins of Molalla reportedly brought the first grain binder to Oregon. The machine-tied grain bundles were fed by hand into a horse-powered thresher. The first horse-powered threshing machine in Molalla was an 1858 Buffalo Pitts owned by Henry Moody. These machines removed the grain from the chaff, or husks, and straw. The steam tractor–powered machines, above and below, replaced the horse-powered threshers. (MAHS.)

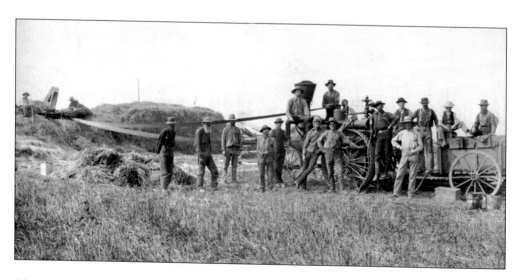

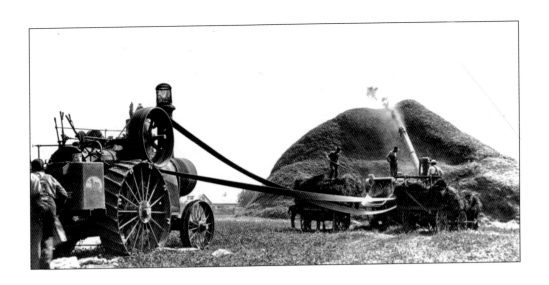

William A. Shaver had one of the first modern threshing outfits for use on his 200-acre farm. This large steam tractor (above and below) powered a threshing machine on the Shaver farm. Steam-traction engines were often too expensive for a single farmer to purchase, so machines would travel from farmstead to farmstead to thresh grain—either oats or wheat. The women and older girls were in charge of cooking the noon meal and bringing water to the men. The men were occupied with driving the bundle racks, pitching bundles into the threshing machine, supplying wood and water for the steam engine, hauling away the freshly threshed grain, and scooping it into the granary. (Carl Cline.)

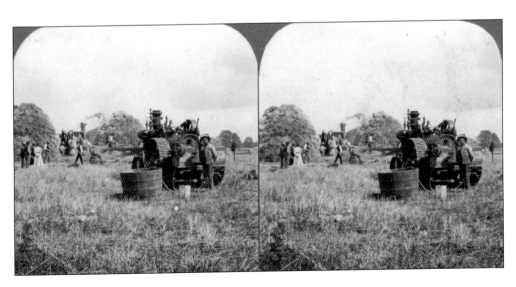

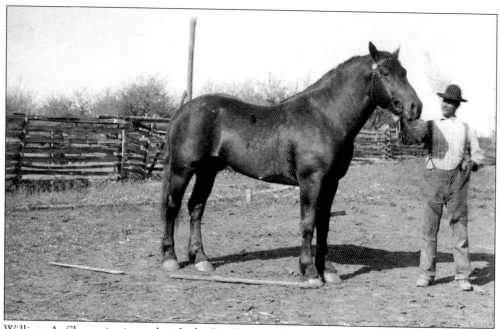

William A. Shaver is pictured with the Percheron stallion Baucis around 1913. Shaver was the area's first breeder of fine draft horses, used for heavy tasks such as plowing and other farm labor. As agriculture advanced, new machines, such as harrows, seed drills, mowers, binders, and threshers, decreased the need for manpower but increased the demand for horsepower. (Iris Shaver Coulson.)

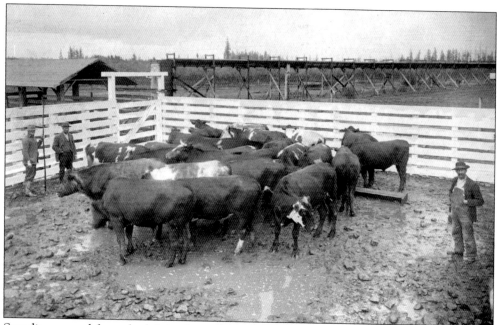

Standing second from the left in this c. 1913 photograph, Shaver sold the first carload of 25 cattle in Clackamas County to the Union Meat Company for $2,200. He was probably the largest breeder of beef cattle in the county, selling 100 to 200 head each year from his 500-acre farm. (Carl Cline.)

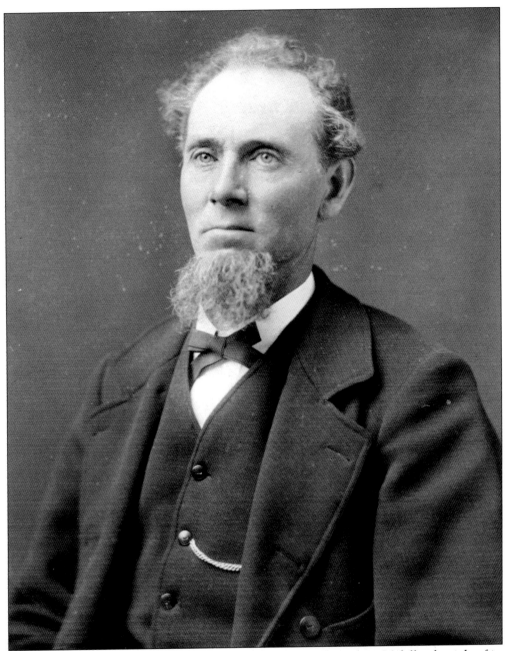

Alfred Joseph Sawtell was the founder and owner of a teasel ranch in Molalla, the only of its kind on the West Coast. Sawtell, born in England in 1839, traveled to the United States with his sister in 1858, following siblings and other family who had settled near Molalla. Educated in the English teasel industry, he brought seeds to plant on his Teasel Creek farm. In 1860, Sawtell sowed his first field of teasel and soon had a manufactory on his farm. He was also the inventor of improved machinery for use in the teasel business. In 1869, Alfred Sawtell married Eliza Dibble, the daughter of 1852 Molalla pioneer Horace Dibble. Sawtell harvested his last teasel crop in 1899, when he sold the business to George H. Gregory. This c. 1890 photograph was taken in New York, the site of the only other American teasel operation. (MAHS.)

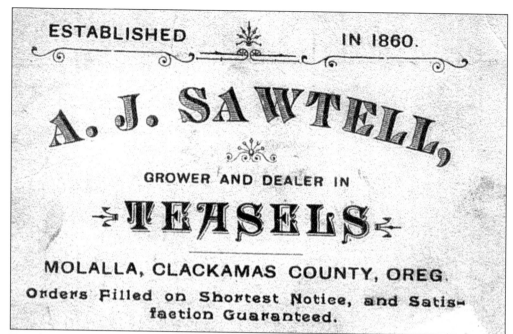

ESTABLISHED IN 1860.

A. J. SAWTELL,

GROWER AND DEALER IN

TEASELS

MOLALLA, CLACKAMAS COUNTY, OREG.

Orders Filled on Shortest Notice, and Satisfaction Guaranteed.

Teasels were grown in just two main locations: Marcellus, New York; and Molalla (noted on the card above). The flower heads of Fuller's teasel, a cultivated non-native species, were used to raise a lustrous nap on woolen cloth in the textile industry. The six-foot plant had stiff bracts with hooked tips on the flower heads that, when dried, were trimmed by hand by women and girls with small, curved knives. The Sawtell teasel farm had a barn, dry house, and trim shed. Chinese workers lived in small houses on the premises while working in the teasels. Wagons pulled by horses (below) took boxed loads of trimmed teasel heads to Oregon City for sale to the woolen mills. The product was also shipped to various places across the country. (MAHS.)

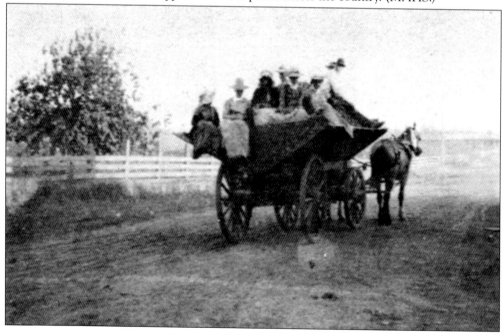

George H. Gregory and his wife, Flora Mohr, are depicted in the above 1919 studio print from an Oregon City photographer. Gregory was a well-known Molalla citizen, town developer, and businessman who took over the Sawtell teasel business in 1899. Born in Somersetshire, England, in 1862, as a boy he came to New York, where he learned the teasel business. He arrived in Molalla in 1898. Gregory crossbred Oregon teasels with New York stock, developing a stronger plant with long bracts. In 1899, he wed Flora Mohr, who had been born in Ohio in 1879. In 1932, the couple built a Tudor-style brick house (below), which still stands in Molalla. (Judy Gregory Kromer.)

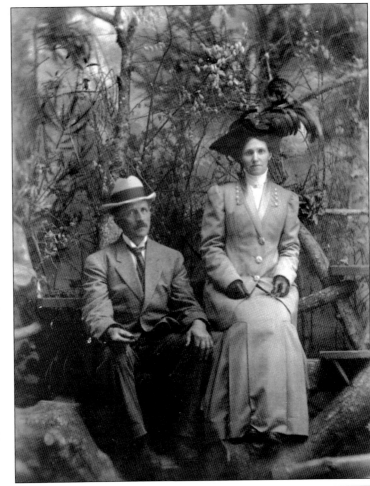

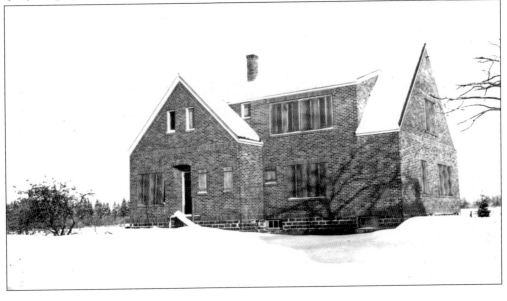

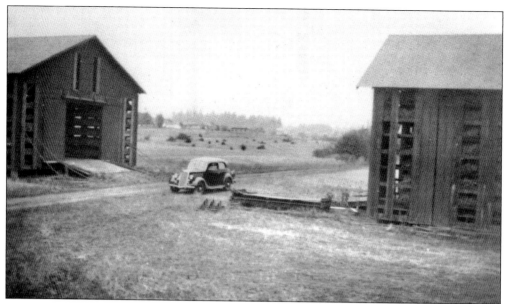

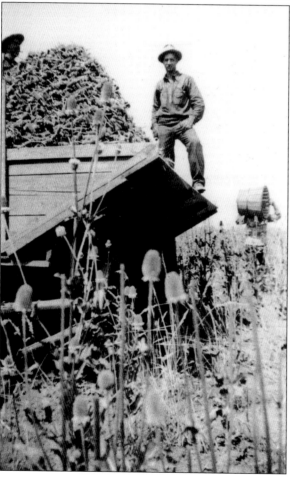

These two *c.* 1910 Gregory teasel barns (above) were formerly located west of Molalla. In this later view, the doors on the sides of the barn are propped open with sticks to provide airflow for drying teasel heads. The barns had a single central cupola for vertical air draw, and each had a central drive-through for loaded wagons. The interiors featured a track-and-pulley system that lifted the wagons up to one of eight stacked shelves for unloading. George Gregory became the only teasel grower on a commercial scale west of New York State, and his product was shipped all over the world. When Gregory died in 1946, the business was carried on by his son Jack, shown below with a loaded wagon of teasel. The Gregory teasel operation closed in 1959. The last of the large barns burned in a huge conflagration in 1971. (Judy Gregory Kromer.)

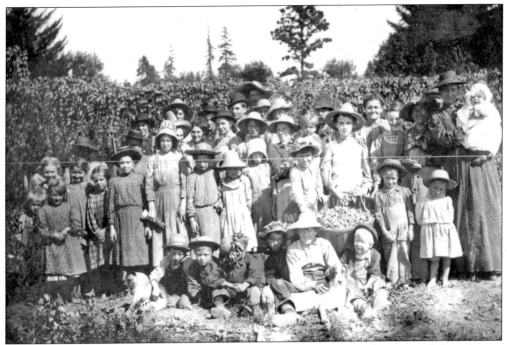

Hop yards were places of laughter and song as people enjoyed a profitable outing while gathering and harvesting the crop. Hop farming began in Oregon in the 1880s. Providing a flavoring agent for the beer industry, Oregon hops became a world leader in quality and flavor. The hops were picked into baskets and then taken to a dryer, where they were spread in kilns that were heated with wood-burning stoves. The moisture was released through a ventilator in the top of the hop barns. Above, at the Jordan hop yard in 1898 are the Sawtell, Everhart, Dibble, Eby, Daugherty, Fox, Dart, Hibbard, Ogle, Judd, Oswalt, Jordan, and Thomas families. The photograph below was likely taken around the same time. (MAHS.)

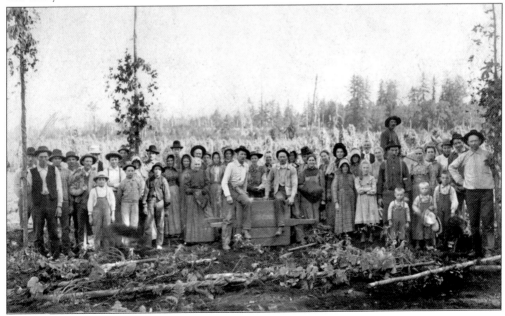

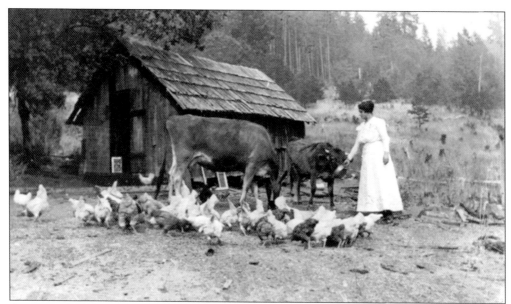

A woman feeds her cows and tends her chickens on the Davies farm in Dickey Prairie. Women often relied on butter and egg money for their own personal supply of cash. This photograph is from the Ivor Davies collection. (Susanna Davies.)

Willard Robbins built this rare, Gothic-influenced barn in 1909 using hand-hewn beams and a pointed-arch window from the former 1862 Levi Robbins's house. Willard and his wife, Annie Lillie, were graduates of the State Agricultural College who wed in 1888. Willard helped run the Robbins Brothers Store in Molalla, sat on the city council, and served as the clerk for the school district. (Carl Cline.)

The Arthur Dunrud farm was a fine example of a mid-20th-century Molalla-area farm. The 55-acre operation specialized in red creeping Rainier fescue, one of only two such businesses in Clackamas County at that time. Arthur Dunrud also ran sheep and cattle here. The Dunruds had the typical regional farm with barns, a water tower, fields, and an orchard. (MAHS.)

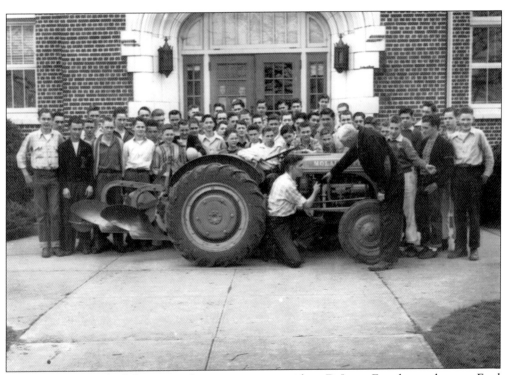

Ralph L. Holman (right), seen with organization president DeLane Fry, donated a new Ford tractor with plow attachment to the Future Farmers of America at Molalla Union High School in 1947. The class of 1947 was the largest Future Farmers of America chapter in Oregon, numbering about 50. Members won the Earl R. Cooley Memorial Trophy that year for the first time. (Reina Holman.)

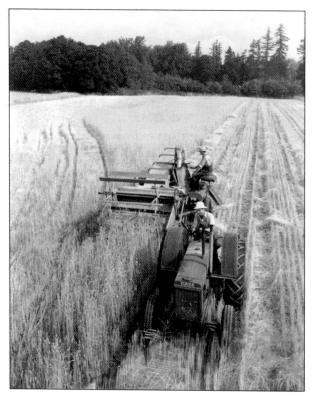

Jim and Alfred Shaver (below) try out new equipment during a photography shoot for the Case Tractor Company on their farm outside Molalla in the 1950s. The tractor and combine came from the Anderson Tractor and Implement Company in Canby. In the above image, Jim sits on the tractor while Al is on the combine. The Shavers were 1852 Molalla pioneers. Alfred Shaver, born in 1901 on the family farm, attended Oregon Agricultural College and served as the first manager of the independent Molalla Telephone Company. He was active in several fraternal and civic organizations and sat on the board that established Clackamas Community College. (Iris Shaver Coulson.)

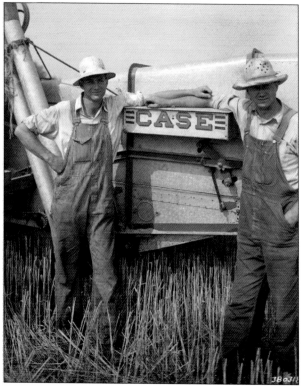

Three

1913

MOLALLA CROWS ITSELF HOARSE!

Molalla suffered an early reputation as a rough-and-tumble town, but all of this changed in 1913 when Molalla became an incorporated town with a population of 240. It was the first city in Oregon to do so under a new state law. At the time, Molalla was considered the most enterprising and rapidly developing city in Clackamas County. It was situated in a "garden spot" amidst a wealth of natural resources. With an eye toward incorporation, the local Commercial Club had implored the people to make their city attractive so that visitors would be impressed. Attorneys drew up a petition presented to the county court asking politicians to call an election so that Molalla citizens could vote on incorporation.

Once it happened, Molalla not only celebrated town incorporation, but also the arrival of the first steam train—the Portland, Eugene, and Eastern Railway. The first train arrived from Canby on September 19, 1913. In addition to bringing celebrants to town, the railroad created statewide recognition, encouraged outside trade and communication, fostered town growth, and gave the community an outward pride. The huge celebration was presided over by the Goddess of Liberty while crowds from Portland, Oregon City, and outlying communities arrived to help commemorate the two biggest events in the town's history.

A city council was put into effect, and W. W. Everhart was elected the first mayor on October 4, 1913. The original council members were Levi W. Robbins, W. T. Echerd, I. M. Toliver, A. T. Shoemaker, W. M. Mackrell, and Fred M. Henriksen. D. C. Boyles acted as the first city recorder; F. G. Havemann, treasurer; and Fred R. Coleman, town marshal. The weekly *Molalla Pioneer* was first printed on March 7, 1913, by town promoter and newspaper editor Gordon Taylor. Construction started on Molalla's new school building for primary and secondary grades that year. Unfortunately a sad event marred the end of the celebration: the death of Chief Henry Yelkes.

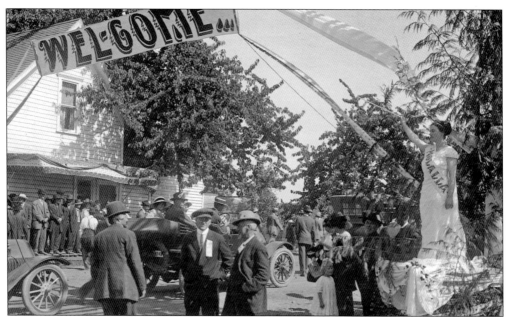

Standing on a draped platform as the Goddess of Liberty, Nina Dunton (Elkins) points to a banner across the street to welcome visitors during a large celebration heralding the arrival of the Portland, Eugene, and Eastern Railway on September 19, 1913. The house in the background belonged to Molalla postmistress Anne Clifford, whose father was the town's first postmaster. (Molalla Public Library.)

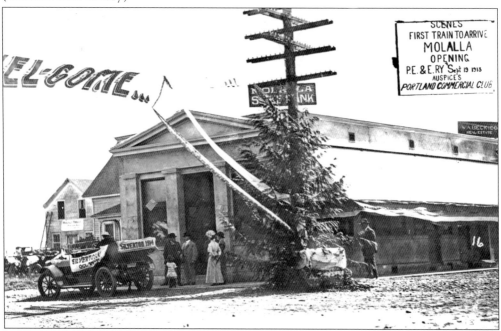

Nina Dunton's station as mistress of ceremonies was the 1913 Molalla State Bank building, which still stands at the corner of Main Street and Molalla Avenue. The *Molalla Pioneer* newspaper, established that year, was housed in the old store building on the left. Silverton sent a special delegation car to the event. (Marie Wells.)

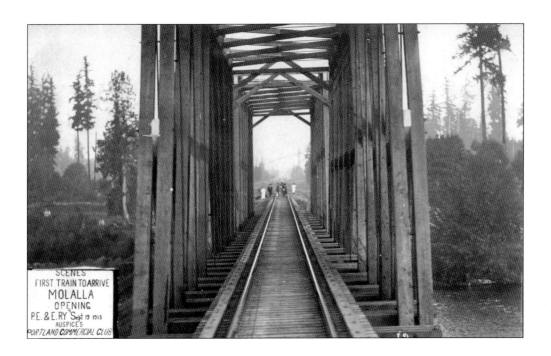

The people of Molalla (below) eagerly awaited the arrival of three trains on the celebration day. The Portland, Eugene, and Eastern Railway was later operated by Southern Pacific as the Molalla Branch. The above photograph shows a wooden trestle over the Molalla River. Hundreds of automobiles from Oregon City, Woodburn, Silverton, Salem, Canby, and elsewhere arrived alongside a procession of wagons and carriages. C. C. Chapman brought a large delegation from the Portland Commercial Club, and Henry Pittock, proprietor of the *Oregonian* newspaper, gave a speech. (Above Molalla Public Library; below Marie Wells.)

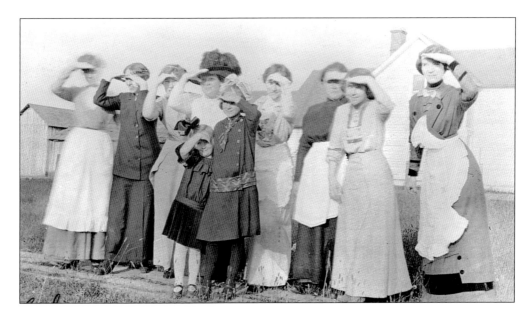

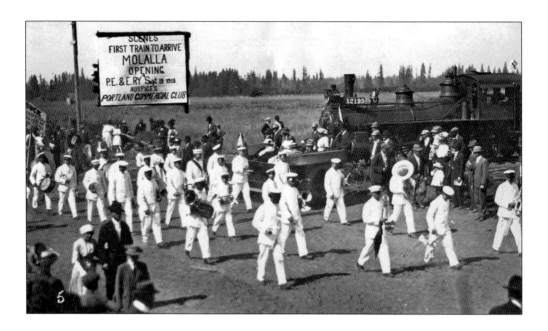

Brass bands from Silverton, Canby, and Molalla marched in a procession from the train depot (above) to a tent where speeches were made. Pres. R. E. Strahorn of the Portland, Eugene, and Eastern Railway made the first address to the crowd (below). Special automobiles bearing Molalla pioneers rolled through town. Music was provided by Molalla's 30-piece band, and events included a baseball game and various attractions furnished by concessions. An exhibition of livestock and agricultural products showcased samples of field corn and tobacco products. Albert Moshberger drew the lucky number for a free town lot. Festivities closed with dancing. The old crossroads town changed that day into a modern city. (Molalla Public Library.)

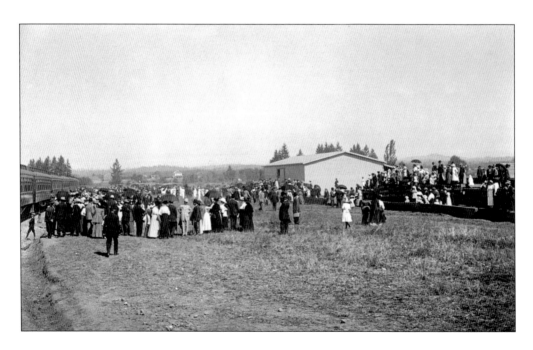

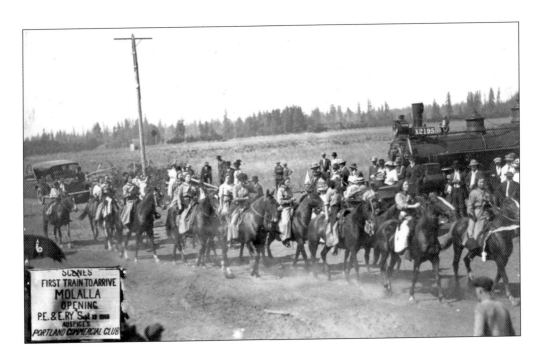

Following the band and crowds were 40 to 50 khaki-clad cowgirls who rode out to greet the arrival of the trains (above and below). The cowgirls, carrying pennants reading "Molalla," were described in the *Molalla Pioneer* as "some of Molalla's fairest daughters." Many of the girls put on a small Wild West show and participated in horseracing and bronc-busting. The outgrowth of these festivities was the Molalla Buckeroo, which is still held every year on the Fourth of July. Several cowboys were on hand to compete in bronc-busting and bull-riding events. The bronc-busting contest earned the winner a $50 saddle. I. J. Jamison rode his star bronco named Headlight. Molalla has always been a horse town where beloved horses are still recalled years later. (Molalla Public Library.)

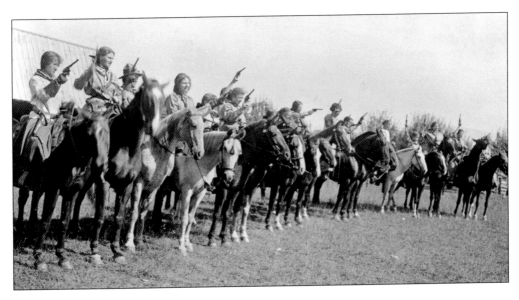

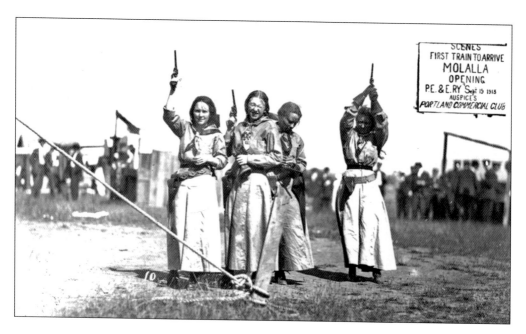

Four cowgirls with leather holsters on their hips fire six-shooters to herald the arrival of each of three special trains and to welcome guests to the celebration. Pictured in the above photograph are, from left to right, Ione Robbins, Agnes Clifford, Mabel (Marsh) Schoenborn, and Maud (Marsh) Jackson. The girls are standing in an empty lot behind the present city hall. G. J. Taylor, the newspaper editor who started the *Molalla Pioneer* in 1913, did much to promote Molalla and to "Make Molalla Move" as he introduced the speakers at the ceremonies. Judge Dimmick spoke in a tent just to the left and behind the girls. The cowgirls fired their pistols in the air to accentuate his witticisms. (Molalla Public Library.)

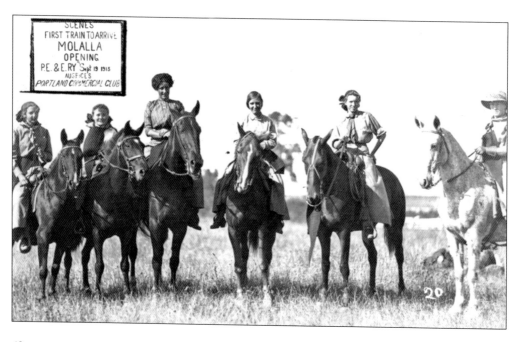

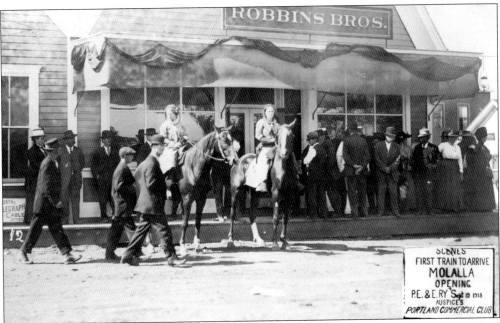

Cowgirls gather with crowds at the Robbins Brothers Store in Molalla. The shop advertised all manner of fabric, including gingham, flannel, silk, muslin, and embellishments such as ribbons, lace, and embroidery. Clothing for women, men, and children was featured, as well as cans of corn and packages of seeded raisins. (Molalla Public Library.)

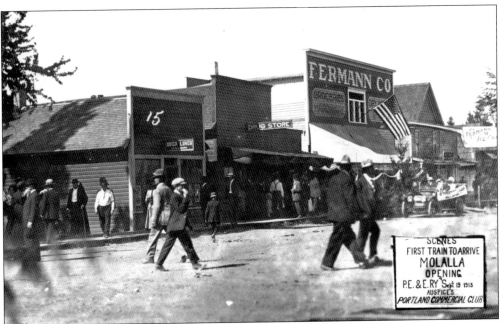

The Fermann Company Store, near the northwest corner of Molalla Avenue and Main Street, featured groceries, hardware, and dry goods. Judging by the sign, the shop undoubtedly sold lots of ice cream during the 1913 celebration. An estimated 5,000 people attended the festivities. (Molalla Public Library.)

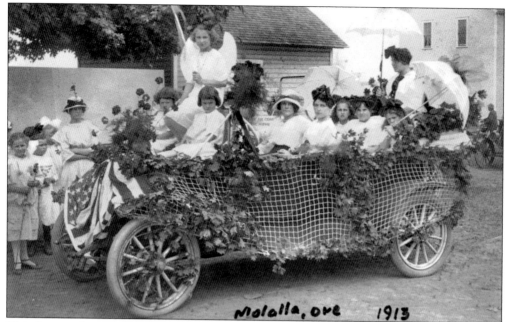

This decorated car, with girls and women dressed in white with fancy hats, bows, and parasols, was part of the Fourth of July parade in 1913. The lead "angel" reigns over her court. Dating to at least 1911, the parade remains a major Molalla event today, in conjunction with the famous Molalla Buckeroo rodeo. (MAHS.)

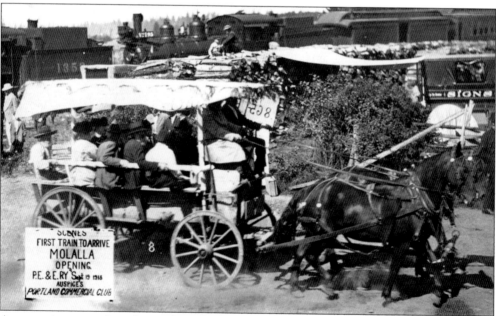

An excursion wagon brought people to the various events during the two-day celebration. Visitors came from all over the Willamette Valley in cars and buggies, on horseback, and even on the trains. From the time the first train arrived in town until the last automobile drove away late in the evening, it was a gala event that was long remembered in Clackamas County. (Molalla Public Library.)

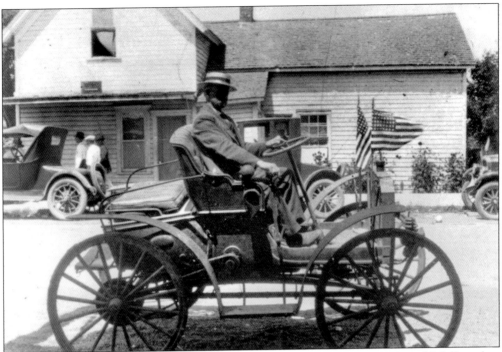

Dr. John W. Thomas was a local pioneer dentist and one of the first people in Molalla to buy an automobile. He drove this 1906 Schacht Auto-Runabout with a 20-horsepower, two-cylinder engine from 1908 until 1918. This photograph was taken during the 1913 celebration, when hundreds of motorists were visiting town. (MAHS.)

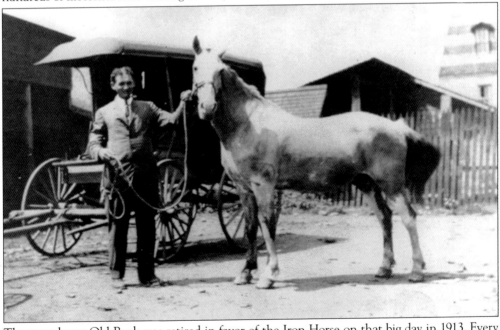

The stage horse Old Buck was retired in favor of the Iron Horse on that big day in 1913. Every day for nine years, Old Buck had made the trip from Molalla to Oregon City with mail and passengers. Here the stalwart horse is shown with Jack Vernon. (MAHS.)

Clackamas County treasurer W. W. Everhart took the oath of office as Molalla's first mayor on October 4, 1913. Everhart also served on the Molalla School Board, worked as a land agent, and owned one of the finest houses in town. Other early Molalla mayors were Fred Henriksen, Ralph Holman, W. T. Echerd, H. N. Everhart, and W. J. Avison. (MAHS.)

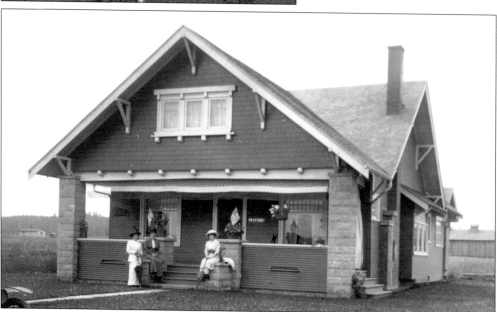

Dr. E. R. Todd's 1912 house, located on South Molalla Avenue, is a noteworthy example of the Craftsman bungalow style of architecture popular during this period. The house was built in the Gregory Addition soon after it was platted in South Molalla. Dr. Todd was well known in town as a "horse and buggy" doctor, serving as the first and only physician for many years. (MAHS.)

Four

FROM WILD WEST TO BUCKEROO

The Molalla Buckeroo, the famous Fourth of July rodeo, began in 1913 as a small bronc-busting event and turned into a Western show and annual round-up. The Molalla Buckeroo Association formed in 1913 to assume the production and promotion of the rodeo, and by 1925 a rodeo arena had been improved near the northwest corner of Main Street and Molalla Avenue.

The yearly rodeo event escalated in 1928, when Umatilla Indians set up a teepee village and participated in the parade and races in their ceremonial dress. At that time, the local citizens incorporated the Western show as the Molalla Buckeroo, copyrighting the word with an "e" rather than an "a." The Buckeroo Board of Directors and a management committee brought rodeo cowboys, trick riders, fancy ropers, and arena exhibits to the annual event. In the 1930s, stock was driven from Harney County via Government Camp and across the Molalla River with a chuck wagon tagging along behind. This spectacle was filmed by International Newsreel and shown all over the country.

Molalla's title of Goddess of Liberty, used for celebratory events, was replaced by the Queen of the Buckeroo in the 1930s. The first queen was Anita Cole Powers, who reigned over a court of avid horsewomen whose duties were to help the queen promote the Buckeroo. The Buckeroo Association used profits from the rodeo to support an ambulance fund and a community cannery and to promote rural fire protection and sustain the library. The benefits thus went to the community that supported it. Professional cowboys competed for prize money, and many famous world champions came through Molalla, such as Casey Tibbs with his fancy clothes and car.

Memorable events have included appearances by Fred Yelkes; a Molala Indian in ceremonial attire; Monty Montana and his family, with a trick riding, roping, and bullwhip act; stagecoach racing; Roman chariot racing; and cowboy and cowgirl races. Other well-known past acts were Range Rider and Dick West, Lassie and Jeff, Gene Autry, and Annie Oakley.

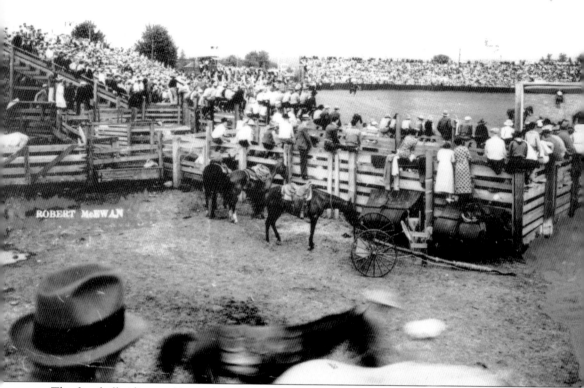

ROBERT McEWAN

The first bull-riding and bronc-busting event in 1913 was so well received that each fall a small Wild West show was staged in a grove outside of town with stock animals obtained locally. One year (1916 or 1917), the city council decided to sponsor the event and was surprised the profits amounted to $1,800. The show moved into town when the city purchased William Shaver's ballpark, near the northwest corner of Main and Molalla Streets. The baseball stadium was improved to

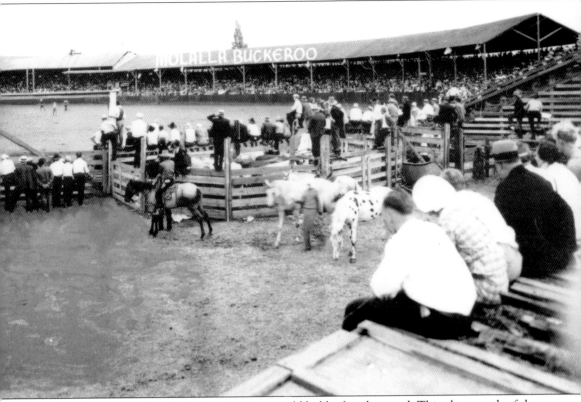

hold 300 spectators, but by the late 1930s, it could hold a few thousand. This photograph of the old grandstand was taken on June 28, 1936, before the west stands were built. The former baseball stadium section was torn down in 1953 and replaced by a new section. (Oregon Historical Society Photograph No. CN000572.)

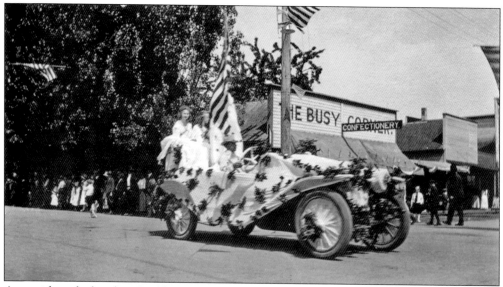

An unidentified rodeo Goddess stands behind the flag around 1920. The same car was used for Goddess Gladys Baty (Bany), who reigned over the big event in 1918. (Howard and Ruth Heinz.)

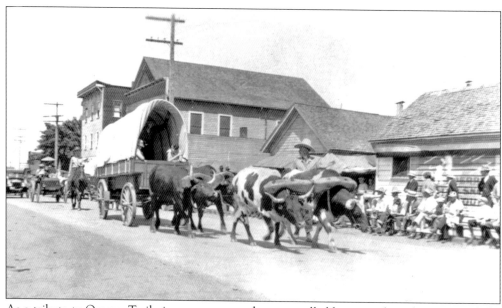

As a tribute to Oregon Trail pioneers, a covered wagon pulled by two yokes of oxen joined the Fourth of July parade during the 1923 show, sponsored by the American Legion. Native Americans, wild horses, the famous bucking horse Battleground, and bucking mules were featured. A Smithson steer threw its rider, broke loose, and was not found for several days. (MAHS.)

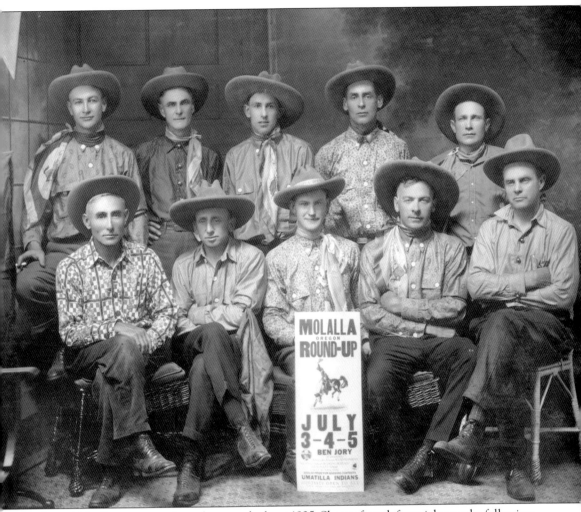

Round-Up directors pose for a photograph about 1925. Shown from left to right are the following: (first row) Fred Park, Paul Robbins, Arthur Farr, Henry Dahl, and Jim Riddell; (second row) Sid Powers, Mort Cochrell, Walter Taylor, Bob Masterton, and Bill Miller. The Round-Up was a major success in 1925, with over 4,000 people attending. Ben Jory of Hermiston managed the show and provided a string of wild and bucking horses. Salty Steer and Bucking Buffalo of Pendleton were other attractions, and more than $2,000 was awarded in cash prizes. Arena contests, a street parade, and an arena parade were also featured. Anita Cole Powers held the first official Queen title in 1925 and reigned with princesses Bernita and Reva Everhart. Umatilla Indians dressed in their native costume, performing war dances and traditional exhibitions. (MAHS.)

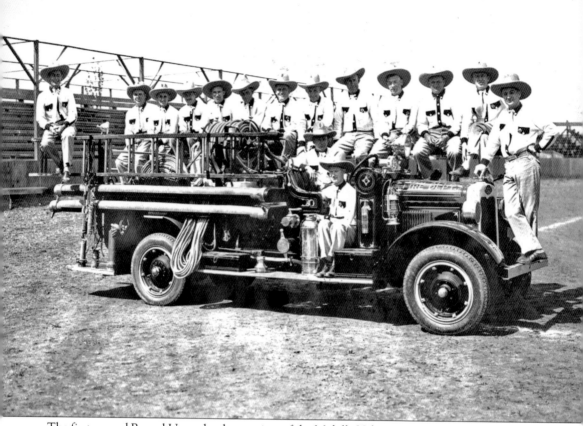

The first annual Round-Up under the auspices of the Molalla Volunteer Fire Department occurred in 1925, when the organization had just one truck. The department, which donated the proceeds for municipal purposes, was able to purchase modern firefighting equipment with the money every year. By 1929, it was the best-organized and most effective volunteer fire department in the state. The 1928 Round-Up was hosted by the newly formed Molalla Buckeroo Association, but the fire department still held the annual Fireman's Queen's Dance and remained actively involved. This photograph was taken on June 28, 1931, with Harry Harvey in the driver's seat. Arrangements were made for the firemen to wear cowboy hats and shirts in 1926, the first big Round-Up year. (MAHS.)

The 1935 Buckeroo program featured a bucking bronco drawn by George A. Dowling, a well-known Western artist. Buckeroo Queen Nell ruled the event that year. The rodeo included a championship bareback-riding contest, a calf-roping contest (total prize $400), a steer-riding contest, bronc riding, bulldogging, and separate cowboy and cowgirl free-for-all races. Monty Montana and his wife and Ed and Tillie Bowman performed trick and fancy roping and riding exhibitions. Montana, a fixture on the rodeo circuit, appeared in a number of John Wayne movies and made headlines in 1953 when he roped President Eisenhower as a gag during his inaugural parade. A wild horse chariot race, a relay race, exhibition steer riding, a Roman standing race, and the Buckeroo Derby were also held. After the show, people could cool off with a draft of Salem beer at Ben's Fountain Café or dine at Sailor's Confectionery and Restaurant. The headquarters for the cowboys and cowgirls was the Buckeroo Trail Big Bar. (Delores Williams.)

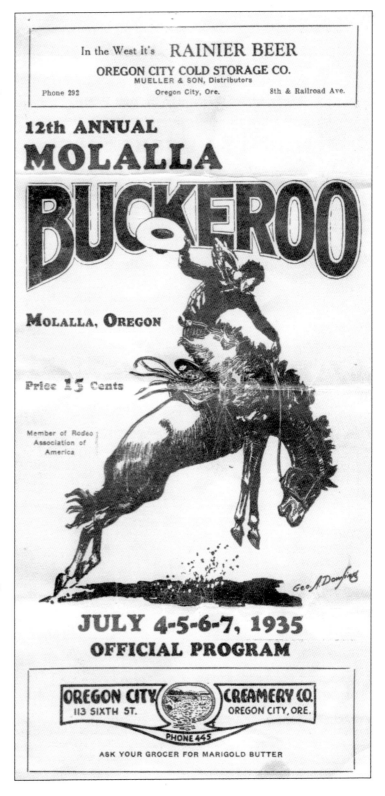

12th ANNUAL

MOLALLA

BUCKEROO

MOLALLA, OREGON

Price 15 Cents

Member of Rodeo
Association of
America

Geo. A. Dowling

JULY 4-5-6-7, 1935
OFFICIAL PROGRAM

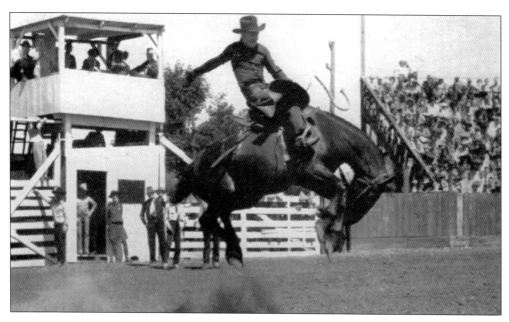

The 1944 Molalla Buckeroo brought Nick Knight (above, on Manager) and another famous rodeo star Gerald Roberts (below, on Hundred Grand) to compete before a sell-out crowd. Gerald Roberts was all-around world champion cowboy in 1942 and 1948, world champion bareback rider in 1946, and all-around cowboy at the Buckeroo in 1947. Another famous 1940s cowboy was Harley May, who won national titles in bronc riding and other events. He also worked as Stoney Burke's double in the old television program of that name. A top cowboy and bareback rider in 1946 was Sonny Tureman, a tall and handsome regular who was also proficient on the harmonica. Famed rodeo clown Wilbur Plaugher competed in the bulldogging event, placing fourth in 1946. (Delores Williams.)

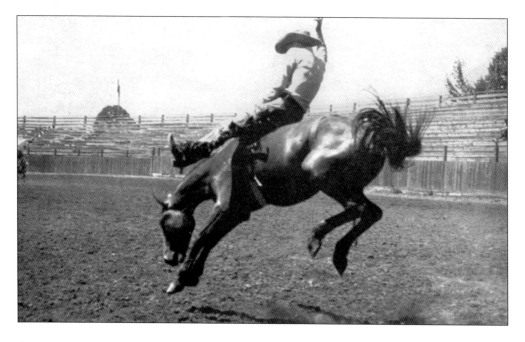

Cowboy Dee Hinton's favorite palomino, Shotgun, was used by ropers and bulldoggers during the Buckeroo events. Called the greatest rodeo horse of all time, Shotgun spent years in fields of clover and ate plenty of fine grain. He was 29 years old at the time of this 1947 photograph. Dee Hinton won the bulldogging contest at the Pacific International in 1940. (*Molalla Pioneer.*)

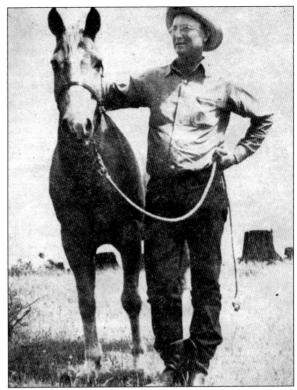

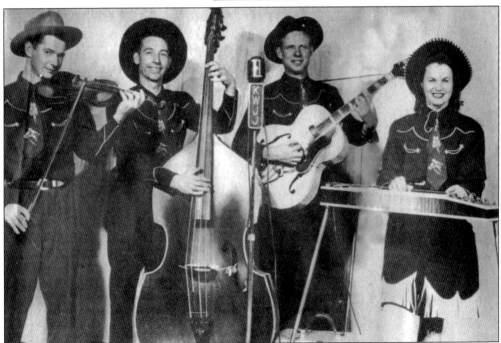

The Western Pals played for the Buckeroo dance crowd during the 1947 rodeo. The band was heard regularly over KWJJ radio and was frequently featured in the Buckeroo program. Pictured from left to right are Buck, Oscar, Benny, and Sugar. (*Molalla Pioneer.*)

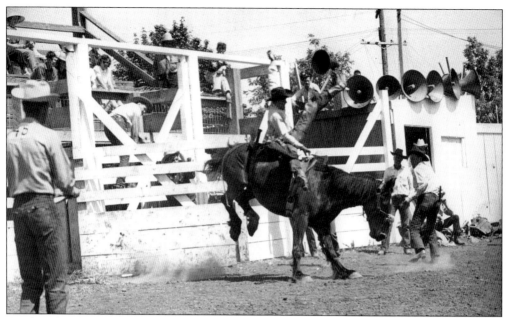

Cowboy Ike Thomason rides Keller Special in preparation for the 1949 Molalla Buckeroo. That year, the Oregon City Elks presented the best all-round cowboy with a trophy, and Levi-Strauss presented a pair of Levis each to the best calf roper, wild cow milker, and bulldogger. The afternoon show also included wild horse chariot racing, the bareback scramble, and cowboy and buck racing. (Delores Williams.)

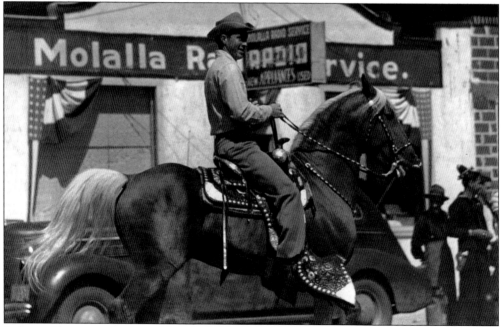

A fancy rider on a palomino with a silver-mounted saddle joins the Buckeroo parade about 1949. Parades were held each morning, with awards going to the best in these categories: Western riding group, sheriff's posse, and Western-style couple, lady, and man. The trophies depicted a saddled horse on a pedestal. (Delores Williams.)

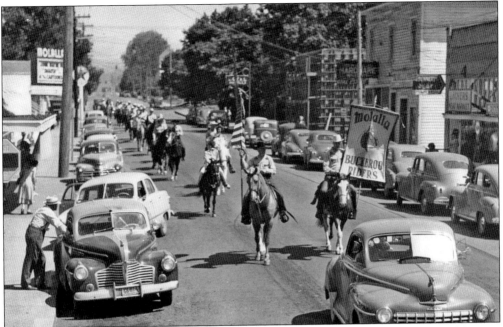

The Molalla Buckeroo Riders participated in the big street parade for the Fourth of July celebration in 1949. Several saddle clubs, the high school marching band and majorettes, and individuals took pride in the summer spectacle. Construction of a new bank building is shown in the background. (Delores Williams.)

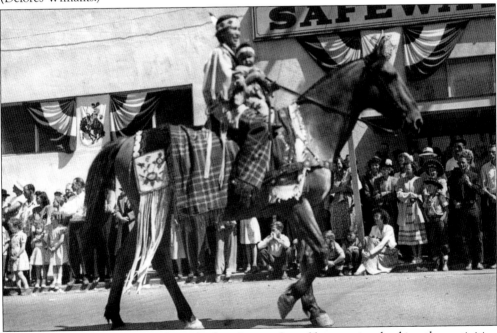

Warm Springs Indians rode and marched in the parade and became involved in other activities. During the 1949 celebration, five Native American girls in traditional dress, ranging in age from 17 to 22, were members of the Honorary Court of Queen Kathryn Erickson. A Native American pageant, called Hiawatha, was presented during the evening. (Delores Williams.)

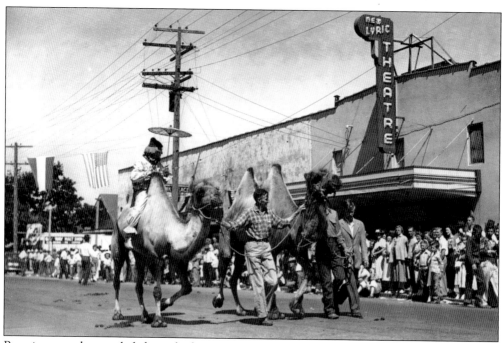

Bactrian camels were led through the streets of Molalla during the *c.* 1952 Buckeroo parade. Trophies for the best contestants in the parade were provided by the following donors: Pearl's Café, Terminal Café, Molalla Variety, the Spot, Molalla Cleaners and Dyers, the *Molalla Pioneer*, Frank's Place, Slim's Place, Kendall's Market, and the Ice Cream Bar. (Delores Williams.)

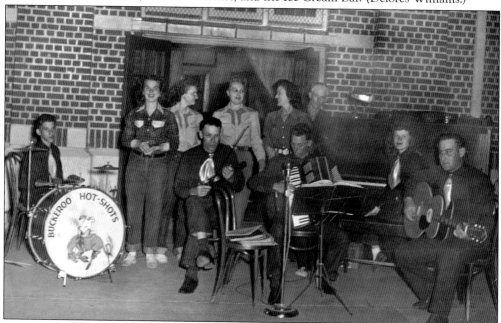

Like all Buckeroo celebrations before and since, a free public dance occurred, sometimes on the high school tennis court, with music supplied by the Molalla Hot Shots. Prizes were awarded for the best Western attire. The Hot Shots played over KGON radio during the three-day Buckeroo event. (Delores Williams.)

Ernest W. Clark, for whom Clark Park is named, was the Molalla Buckeroo Association president in 1950. At the time, the Buckeroo was declared to be the largest round-up in western Oregon. Natives of New York, Clark and his wife owned and managed the Molalla Theatre, which opened in 1948, and co-owned the Lyric Theatre. (Allan DeFabio.)

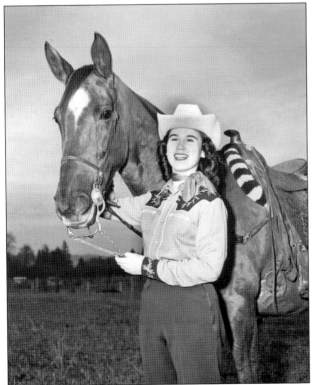

Marilyn Sawtell Behrends, pictured in fine Western attire with a favorite Sawtell horse, was crowned Molalla Buckeroo Queen in 1954. The Sawtells have furnished riding stock for the rodeo event since its beginning. Marilyn was a member of the Milwaukie Riding Club and attended Oregon State College. (Marilyn Sawtell Behrends.)

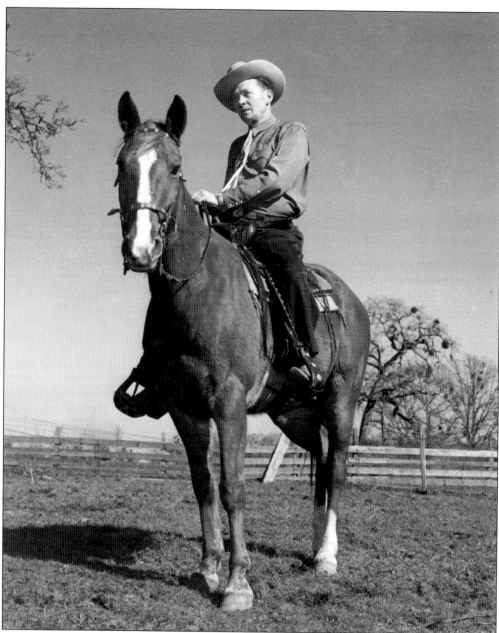

Frank Lowes poses on Rico in a Molalla Buckeroo publicity shot taken in 1954, when he was president of the Buckeroo Association. Rico was a spirited horse belonging to Elmer Sawtell. Largely due to Lowes's efforts, the Buckeroo grew into one of the most famous of Western rodeo events. Lowes was a prominent business and civic leader and owned a tavern in town, Frank's Place, which proved a popular hangout during the festivities. He had previously risen from a lumber hand to the top of the lumbering industry. Born in Detroit, he came to Portland in 1926 and worked for the West Oregon Lumber Company. In 1933, he traveled to Molalla to work for the Molalla Lumber Yard. In the early 1940s, he purchased his first sawmill in town, transforming it into one of the largest in the region, known as the A. F. Lowes Lumber Company. Frank Lowes died in an automobile accident soon after this photograph was taken. (*Molalla Pioneer.*)

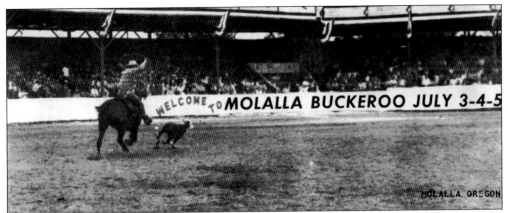

As shown in this 1970 photograph, calf roping combines the roping skill and timing of a cowboy with the quickness of a well-trained horse, each working in unison, to catch a speeding calf. During the timed event, the calf is caught and three of its legs are tied with a "piggin string" before the timer is stopped. A calf then has five seconds to try to kick free. (Delores Williams.)

This old Concord coach was built in the early 1870s for sightseeing in Yellowstone National Park and is perhaps one of only three in existence today. Owned by the Molalla Buckeroo Association since the 1930s, the coach carried dignitaries in countless parades and brought movie stars to premieres in Portland. It was restored to its original glory in 1979. (Delores Williams.)

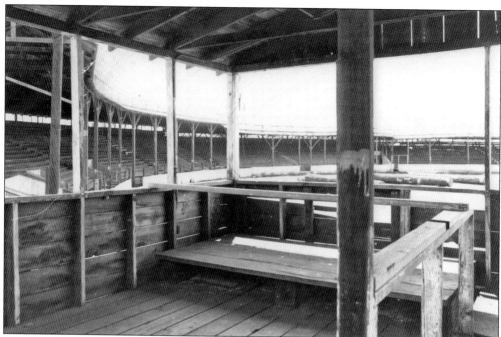

A new Buckeroo arena was built in 1977 (below) to replace the old wood-frame grandstand, a center of attraction for millions of visitors over more than 50 years. The front of the old grandstand housed special box seats for visiting dignitaries and elected officials. The area above the main entrance was the Queen's section with a spot for the band. While the old grandstand (above) was coated with gallons of whitewash and paint, the new one was made from concrete and steel. The Long Branch Saloon was moved to the new space so the cowboys would have something to remember from their past experiences. The Section E-F stands were also retained, along with the bucking chutes. (Above Lois E. Ray and Tim E. Palmer; below Judith Chapman.)

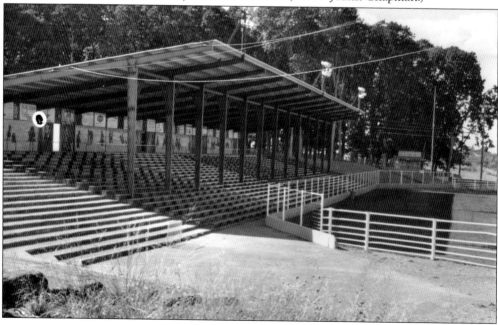

Five

Four Corners
Grow a Town

The old town of Molalla grew up at Main Street and Molalla Avenue, where the earliest wooden false-front shops and service buildings emerged at the Four Corners. Molalla remained a small Western town until incorporation in 1913, when the population crept toward 600 and 25 modern homes and several commercial buildings were constructed, including a harness store, a drugstore, a confectionery and barbershop, a general merchandise store, a meat market, a newspaper printing office, a hardware and implement house, and a furniture store. A telephone system had been in use since 1903, when the first line went in at the Robbins Store. The town was fitted with electricity around 1913, and while the first water supply came from a large well, in 1921 a new water system was laid with a wooden pipeline supply from Trout Creek. With the coming of the first automobiles in the early 1900s, parts of Main Street were planked for vehicle traffic. In 1917, the first street was paved and concrete sidewalks were installed.

W. W. Everhart was elected Molalla's first mayor in 1913, along with the completion of the town's first fireproof building: the bank that remains on the southeast corner. Everhart's Craftsman-style home set the tone for new residential construction. Individual sales in the Kaylor Addition, the Gregory Addition, and the Harless Addition showed a concerted effort toward planned residential building. Another development was promoted by two Portland hop merchants, Metzler and Hart, who bought land near the terminus of the new Portland, Eugene, and Eastern Railway on the west side of town. The development of the brick and tile plant in 1924 facilitated construction of more fireproof buildings by the 1930s, although many wood-frame structures lingered for years. Masterton's Garage, which still stands on Molalla Avenue, was the first brick and structural-clay tile building when completed in the summer of 1925.

The terminals of three railroads—the Southern Pacific Molalla Branch line, the Willamette Valley Southern Railway, and the Eastern and Western logging railroad—offered convenient shipping facilities for Molalla's agricultural and wood products.

One of the earliest known images of Molalla is this view, looking east toward the Four Corners, from which the town later blossomed. None of the buildings in this photograph are identified. The grove of trees on the left is now City Park. (Carl Cline.)

Molalla had gained the appearance of a town by the 1880s. The most prominent building in this image of Four Corners is the long, white store built about 1872 by Ira Moody on the southeast corner of Main Street and Molalla Avenue. The structure became the Robbins Brothers Store in 1892. The tallest building on the left is the 1883 P. S. Noyer (later Fermann) building (MAHS.)

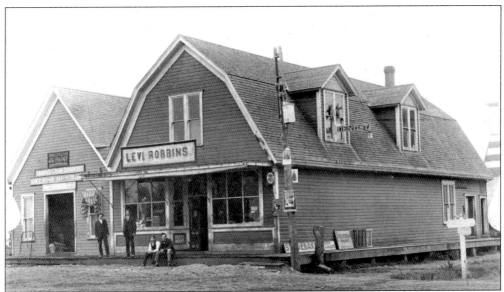

Levi and Harvey Robbins, shown in an 1860 portrait (at right), started the Robbins Brothers Store. Pictured in 1907 (above), the shop was located on the southwest corner of Main Street and Molalla Avenue in a building erected by G. D. Fox, Charles Hogis, and C. P. Little in 1893. The brothers acquired the Fox Store about 1898. In 1915, the building was moved east to the neighboring lot and enlarged. The business advertised all manner of goods, including farm produce, dry goods, groceries, boots and shoes, clothing, sewing supplies, medicines, hardware, plows, and other agricultural equipment. In 1926, the Robbins brothers sold their business to the Molalla Mercantile Company. A 1928 fire completely destroyed the entire stock and structure. (Above Carl Cline; right MAHS.)

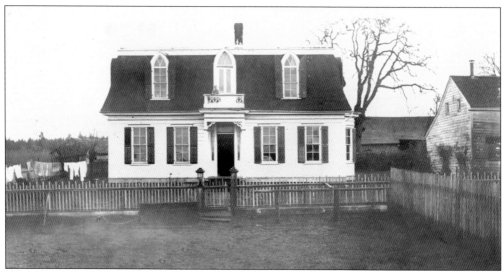

The Asa and Abby Sanders house, built in the early 1870s, still stands in Molalla as a rare example of Second Empire architecture in Oregon. The Gothic-style windows may represent the Methodist religion of Asa Sanders. The child on the balcony in this c. 1900 view is thought to be Golda Harless. (Judy Price.)

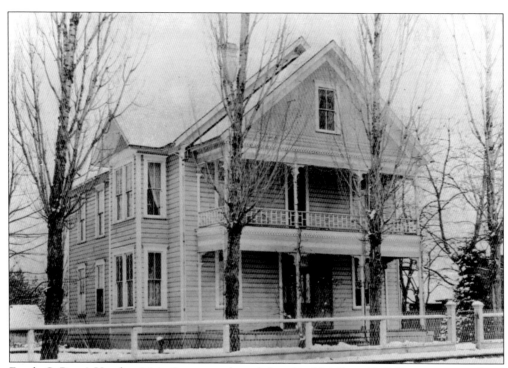

Frank. C. Perry's Hotel on Main Street was the only hotel in Molalla in 1902. Perry accommodated traveling salesmen and summer tourists, ran Molalla Stables, and outfitted camping and mountain trips. A well-known photographer, he had an adjacent small studio with a skylight. The hotel was reportedly destroyed by fire. (Carl Cline.)

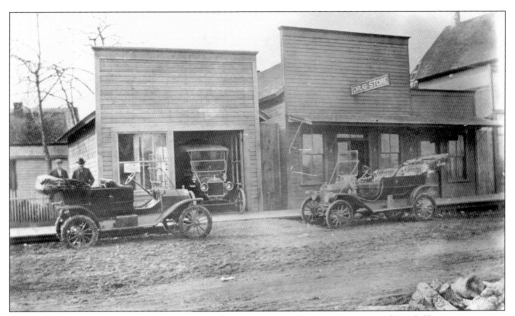

Cole's Garage (left), situated on the northwest corner of Main Street and Molalla Avenue, was a Studebaker and Indian motorcycle dealership. In this 1912 view are Jim Nelton (left) and Cass Herman. The building at center housed a drugstore known as the Fair Store in 1913. The two-story structure on the far right is the Fermann Store. (MAHS.)

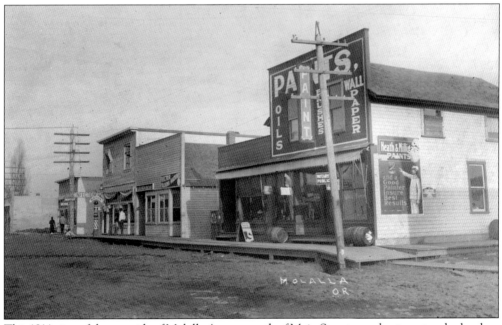

This 1914 view of the east side of Molalla Avenue south of Main Street reveals a two-story barbershop and confection business at left, a music store advertising "Victor Talking Machines" or phonographs, a drugstore, and a paint and wallpaper store on the corner that is still standing. (MAHS.)

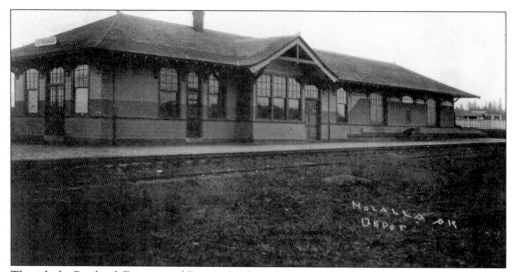

Though the Portland, Eugene, and Eastern Railway depot no longer stands, it was once considered one of Molalla's finer buildings. Shown here in 1914, the building had a loading platform, a freight and baggage room, a ticket office, and a waiting room. The depot was located between Hart and Shaver Avenues on the south side of Main Street. (MAHS.)

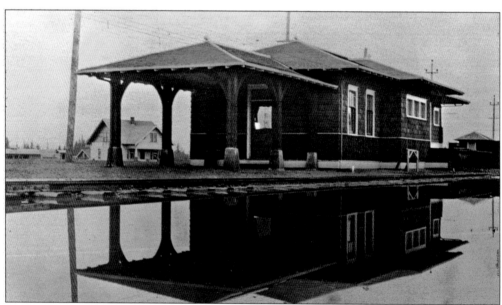

Another good example of architecture no longer remaining is the 1915 Willamette Valley Southern Railroad depot. The Craftsman-style building with shingle siding featured a covered portico and stood between Wittenburg and Dixon Avenues on the north side of Main Street. The electric rail line ran from Oregon City to Mount Angel and Monitor via Molalla, offering freight and passenger service. (Katherine Johnson Oblack.)

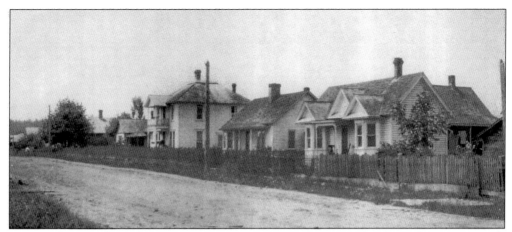

Some of the city's finest homes in 1913 were located on the west side of Molalla Avenue south of Main Street. These rural, country-style houses reflected the Western flavor of Molalla just as the town was approaching a population boom and city incorporation. The year 1913 also brought the railroad and the start of the famous Molalla Buckeroo celebration. (MAHS.)

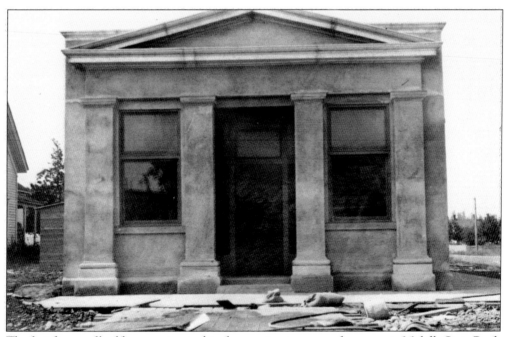

The first fireproof building constructed in the growing town was the concrete Molalla State Bank in 1913. It remains on the southeast corner of Main Street and Molalla Avenue. Levi Wayne Robbins served as the president of the company, which was started with a capital investment of $15,000. Banks were often situated on corner lots and used the Greek or Roman temple-front form with columns. (MAHS.)

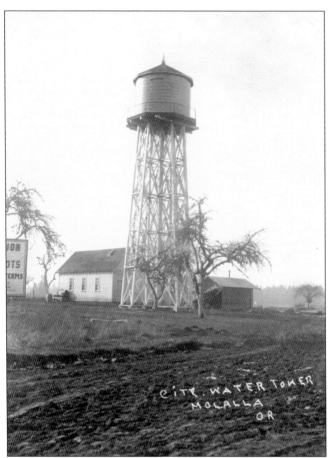

The Molalla Water Works tower, shown in 1914, stood for years at the corner of Section Street and Molalla Avenue. A large-capacity concrete reservoir near the tower held 55,000 gallons of city water. The first municipal supply was accessed in 1921 when water was routed from Trout Creek, southeast of town. (MAHS.)

Hotel Molalla was a large and commodious building with a spacious lawn located where the Chevron service station is today. The hotel, which later catered to loggers, was appreciated for its proximity to the Band Auditorium across Engle Avenue, where dances were held. The hotel was built in 1915 by Dr. J. W. and Mrs. M. A. Powell. Meals and rooms were 25¢ to 50¢ each. (MAHS.)

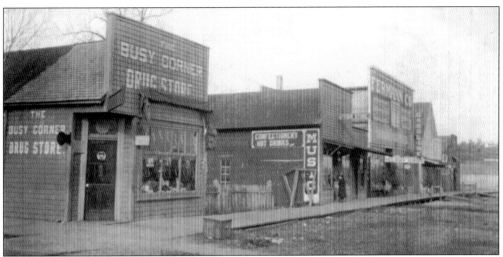

The false-front buildings along the west side of Molalla Avenue north of Main Street line a wooden boardwalk in this *c.* 1914 Christmas view (above). The Busy Corner Drug Store, demolished in 1937, had a long lunch counter that served the first soft ice cream in the area. The Fair Store (center) was a variety store that served candies and hot drinks and had a section for music. The Fermann Company, with Christmas trees outside the storefront, sold dry goods, shoes, groceries, gasoline, oil and paint, and other necessities. Fermann advertised spider leg tea in 1913 (below), a Japanese green tea with long, thin leaves. The Fermann building was one of the oldest in Molalla when it was demolished in 1925 to build the Masterton Garage. (Above MAHS; below *Molalla Pioneer.*)

GET THE HABIT !

Trade at FERMANS and save money

Here are a few Specials for Saturday

100 Large Fine Dinner Plates
Regular 15 and 20 cent values at — 10c

10lb Sack Fresh Corn Meal
Regular 35c — 25c

1 pound Spider Leg Tea
Regular 50c — 35c

Granite Kettle
Regular 20c — 10c

Large Granite Pails — 50c

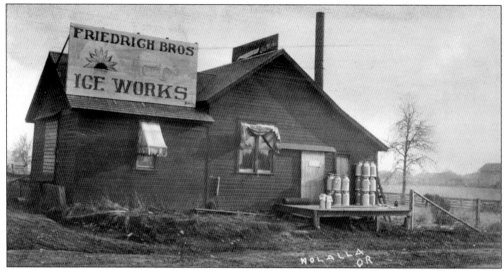

Friedrich Brothers Creamery and Ice Works building, seen about 1910 (above), was situated on Molalla Avenue north of Main Street. Frank and Otto Friedrich were set up in the business by their father, Bernhard Friedrich, in 1908. The creamery was known for its homemade ice cream. In 1922, Otis G. Foglesong owned the Molalla Creamery and purchased cream and eggs from area farmers. The advertised Simplex cream separator (below) was a dairy machine used to separate fresh whole milk into cream and skim milk through centrifugal force. It was much faster than the gravity method since there was less risk of harmful bacteria. (Above MAHS; below *Molalla Pioneer*.)

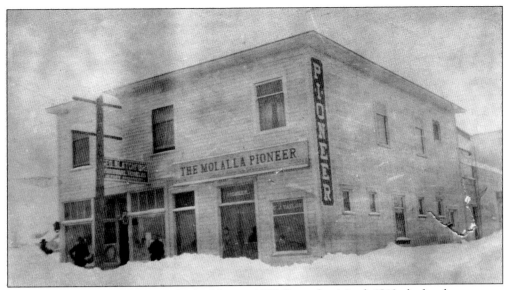

The *Molalla Pioneer* moved into this building in 1915. Started in March 1913, the local newspaper had first operated from the 1870s store building that stood on the corner of Main Street and Molalla Avenue. The east half of the new building was occupied by George Blatchford as a hardware and farm implement shop. (MAHS.)

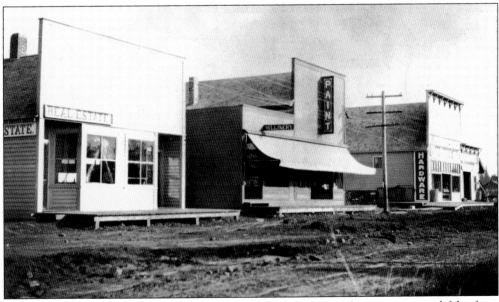

The east side of Molalla Avenue south of Main Street had several new commercial false-front wood-frame buildings in 1913. Along the block are a real estate office (left); a millinery shop, probably owned by Nina Dunton (center); and a paint store. Across Second Street is a hardware store. (MAHS.)

This postcard view, postmarked January 5, 1915, looks east on Main Street toward Four Corners. The three-story building on the left is the New Molalla Hotel, also called the Commercial Hotel. In the center is the Lyric Theatre, followed by the W. A. Wood Billiard and Pool Hall, which featured a barbershop, baths, and cigars. (Dianne Jeli.)

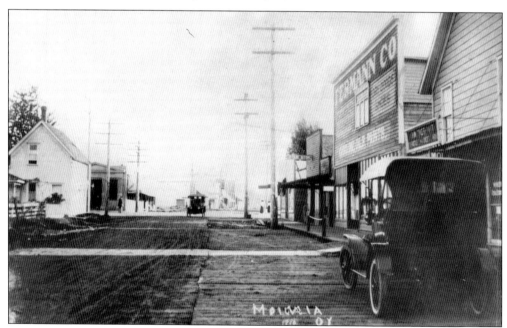

A car is parked on the boardwalk in this 1916 view of Molalla Avenue looking south toward the intersection with Main Street. The Clifford house and post office and the concrete bank building are at left, while the Fair Store and Fermann Company Store are on the right. The wood-frame building next to the parked car stands today. (MAHS.)

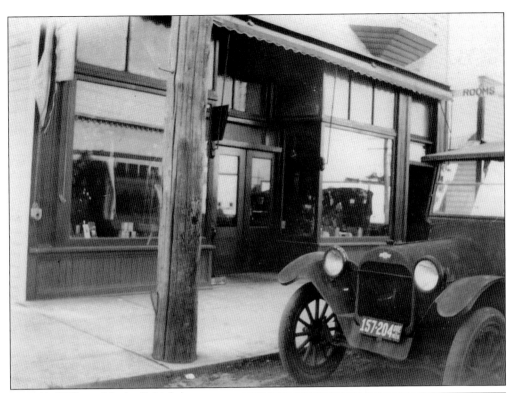

In 1888, William Mackrell (right) became the first harness maker in Molalla. In this 1926 image, he stands on the street corner in Molalla. Mackrell kept books in his shop (above) as a free reading room and is thus considered Molalla's first librarian. He also played in the brass band. William Mackrell's harness shop was built on the west side of Molalla Avenue south of Main Street in 1914. The building featured two projecting bay windows and offered rooms for rent on the second floor. Mackrell's office was in the center of the main floor, and his workroom had a Landis harness machine. Mackrell had the largest selection of harness stock in town. (Oregon State Archives, Secretary of State, OSL0019 and OSL0020.)

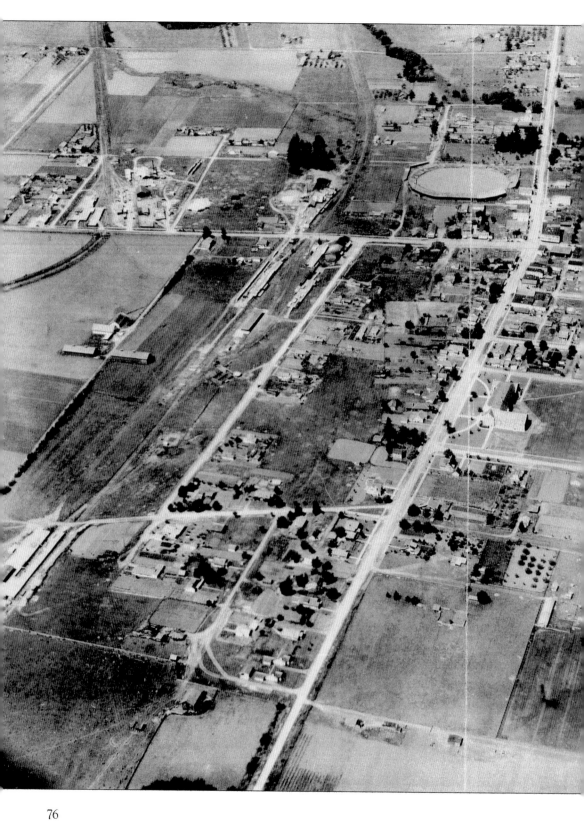

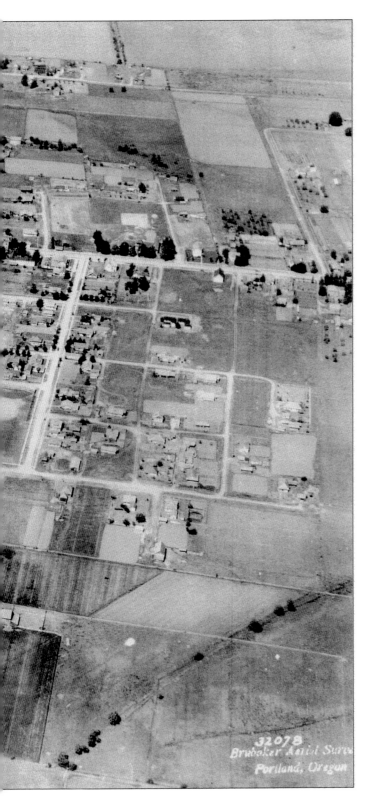

This aerial view of Molalla dates from about 1932 and clearly shows Molalla Avenue running north-south and Main Street crossing it on the east-west line. Two prominent features are the old Buckeroo grounds in the northwest quadrant and the 1926 brick high school in the southeast quadrant. On the left are the two train tracks—the Willamette Valley Southern on the far left and the Portland, Eugene, and Eastern Railway between it and the Buckeroo arena. This image was taken by Brubaker Aerial Surveys of Portland before the big lumber mills moved into town and dominated the landscape. (John Chelson.)

A general merchandise store stood on the corner of West Main Street and Metzler Avenue around 1920. To the right of the shop was the fire hall, with a four-story hose-drying tower to the rear. The hose cart was stored through the open doorway. (MAHS.)

This bird's-eye view of Molalla was taken from the water tower at the intersection of Molalla Avenue and Section Street. The white two-story house on the right is the Frank Dicken house. Behind the home was one of George Gregory's teasel barns at the future site of the 1926 Molalla High School. The long building at top left center is the Band Hall. (MAHS.)

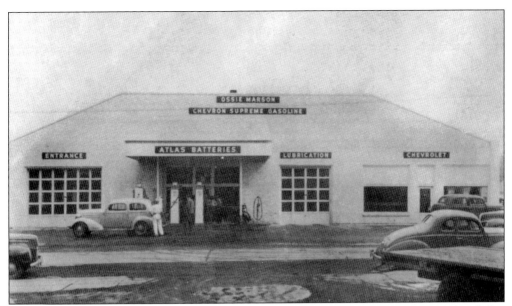

Chevrolet came to town to compete with Ford in 1947, when Ossie Marson completed this building (above), which still stands on Molalla Avenue. The new building was described by the *Molalla Pioneer* as "one of the finest auto service buildings in the Willamette Valley." Marson sold Chevrolet automobiles as the proprietor of the business. He also served as president of the city council, chief of the fire department, and a member of the grade school board. The workers shown in the photograph below are the following, from left to right: (first row) Ossie Marson, Harry Swerver, Pete Ficken, and Dick McGinnis; (second row) Geno Marson, Howard Dickey, and Lloyd Hood. Other employees in 1947 were bookkeeper Frances Oblack, Leslie Coover, and Jack Deeters. (*Molalla Pioneer.*)

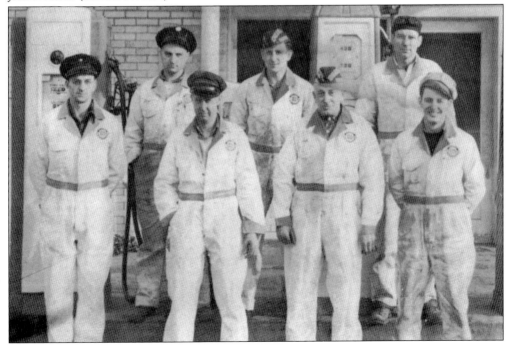

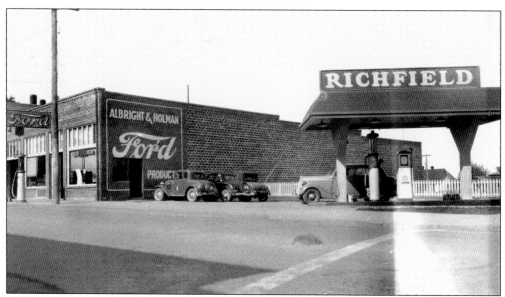

Ralph L. Holman and C. H. Albright purchased Cole's Garage in 1920 and formed the Albright and Holman Ford Agency in Molalla in 1923. Ralph L. Holman was the father of Ralph M., a prominent lawyer and judge of the Oregon Supreme Court, Paul, a ford Dealer, and Charles, dean of medicine at the University of Oregon Health Sciences Center. (Reina Holman.)

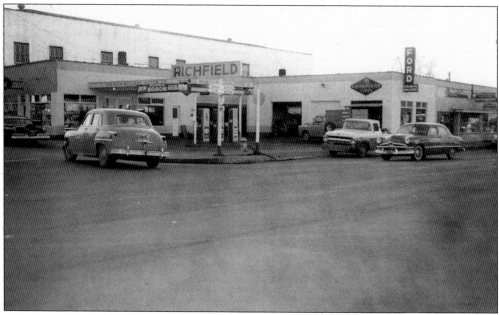

Albright and Holman became the Holman and Williams Motor Company in late 1949. In this 1950s photograph, the building has been redesigned and expanded. It still stands on the southwest corner of Main Street and Molalla Avenue, but the gas pumps are gone. Several businesses have used the building since. (Reina Holman.)

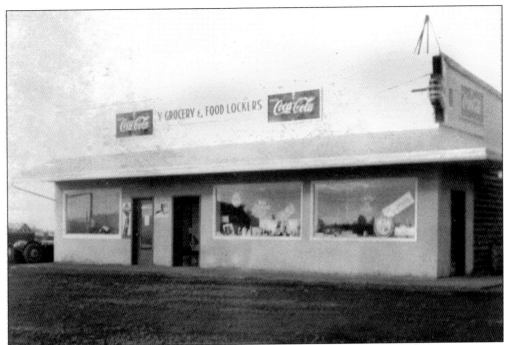

The small Y Market offered groceries and served as a food locker. This 1952 view was taken when the store building was completed on the east end of Main Street. A 1950s advertisement listed 2 pounds of sugar at 19¢, peaches, fryers at 99¢, peanut butter, pink grapefruit, cheddar cheese, 10 pounds of potatoes at 49¢, and tomato juice. (JoAnn Wiegele Olsen.)

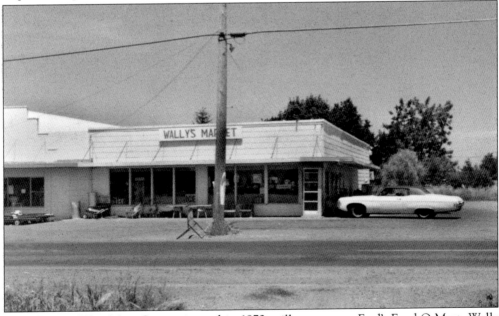

This shop on West Main Store, pictured in 1970, still operates as Fred's Food-O-Mart. Wally and Judy Aho ran the business for years, purchasing the building from Gladys and L. J. Denney in 1964. Feed was sold in the old Quonset hut next to the building, which had once served as a bowling alley. (Wally and Judy Aho.)

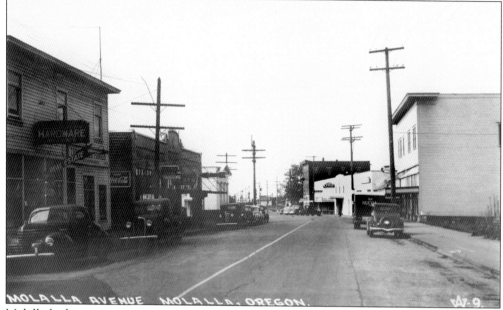

Molalla had grown into a compact commercial city by 1941. A one-story commercial building replaced the wood-frame buildings at right center, housing the new Lyric Theatre, which had been in this spot since the 1915. Also new is the one-story grocery and restaurant building in the left center. The city streets were first paved in 1918. (Bruce C. Helvey.)

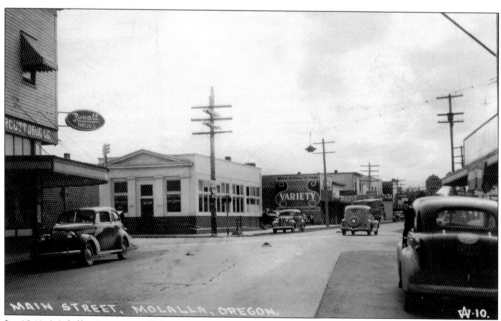

In 1941, Molalla Avenue still had the old wood-frame buildings south of the bank. On the far left, Orcutt Drugstore operated from a two-story wood-frame building constructed around 1920 that would burn in 1944. The structure also housed a general merchandise store and the Odd Fellows Hall. (Dianne Jeli.)

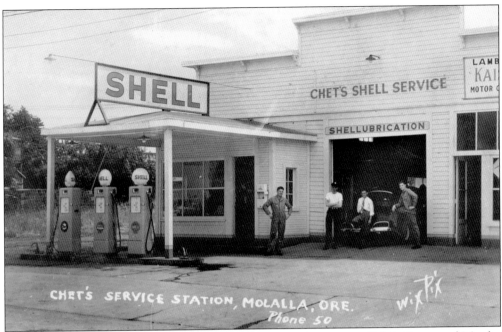

Chet's Shell Service was built as the Molalla Garage on the corner of Main Street and Metzler Avenue before 1915. The second Shell building remains here today, though not as the same business. This 1940s photograph also shows the Lamb's Kaiser-Frazier car dealership. (Reina Holman.)

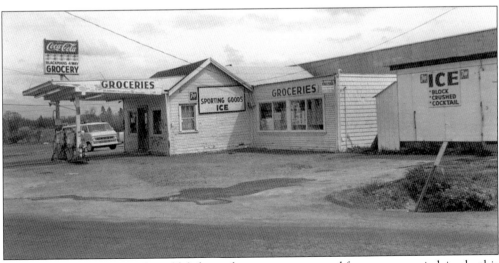

Blackman's Corner retained its old-fashioned country store appeal for many years, judging by this photograph taken in the 1970s, when it was called Blackman's 4-Way Grocery. In 1947, it was Kennedy's Grocery and Gas. Today the business at the corner of Highways 211 and 213 occupies a newer building. (MAHS.)

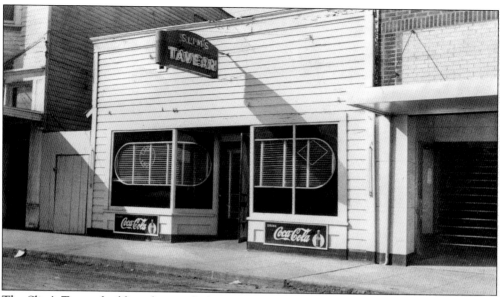

The Slim's Tavern building dates to before 1915, when it was a clothing store. In this *c.* 1950s view, the Mackrell harness shop building is on the left, and the IOOF building is on the right. (Delores Williams.)

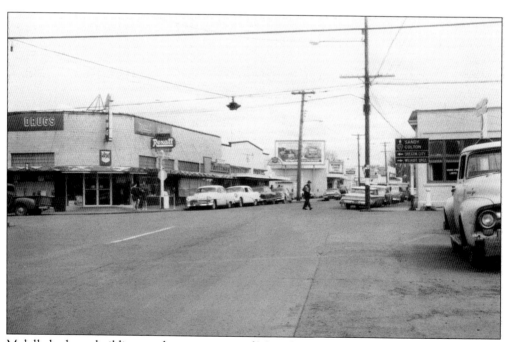

Molalla had new buildings at the intersection of Main Street and Molalla Avenue by 1962. The fireproof Orcutt Drugstore is on the far left; next to it is Dicken's Thriftway grocery store, followed by a large billboard in front of the 1947 Molalla Theatre. All of these buildings remain but have been remodeled. (Ben Maxwell Collection, Salem Public Library, 6448.)

Six

WILHOIT SPRINGS RESORT

John Bagby is said to be the first white man to discover the mineral springs that were later named for John Wilhoit, who took up the land in 1866. Bagby happened upon a couple of mineral springs bubbling out of the ground next to Rock Creek about seven miles south of Molalla. Another source credits Abe and John Larkins as the first to notice and then pass by the springs.

In the 1870s, Frank W. McLeran purchased a part of the property with the thought of building a resort to take advantage of the springs and the public's interest in mineral water cures for all sorts of ailments. His ambitions would lead to the construction of a wonderful array of structures including a bathhouse, bowling alley, hotel, clubhouse, store, band pavilion, and cabins. Wilhoit soared in popularity, with guests arriving from the big cities in droves. The efficacy of the water was touted far and wide, and the resort was compared favorably with the famous baths in Germany. McLeran established a post office in 1882 at the Wilhoit Springs site, and it operated until 1928. He and his family lived in their own home on the grounds: a log bungalow designed to match the log hotel. His store sold camping supplies to the folks who did not wish to stay in the hotel or the many small cottages. Organizations held their picnics on the ample grounds, where Fourth of July gatherings were well attended. The mineral water was bottled and sold locally and in Portland for years.

Fires consumed the first frame hotel and the later log hotel and other buildings. The last structures McLeran had built succumbed to the great windstorm of October 12, 1962—except the band pavilion; after years of weathering, it was taken down by man and machine. In the 1970s, a cottage or two was still standing. All are gone now, save for the building where the present-day caretaker lives. The former resort is now a Clackamas County park, and anyone can come and partake of the mineral water for free.

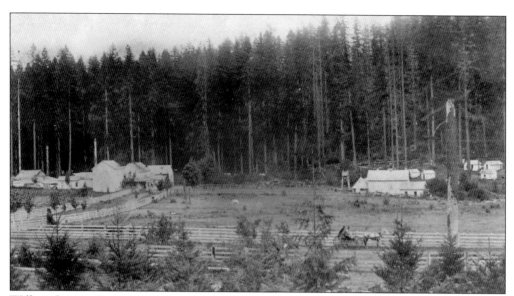

Wilhoit Springs Resort was constructed about 1886 on land claimed by John Wilhoit. The vast acreage was transformed from raw forest to a hotel, summer cabins, and a building that housed a hand pump for filling bottles with soda or sulfur water. People came from near and far to camp among the tall fir trees or to luxuriate in the fine hotel. (Clackamas County Historical Society.)

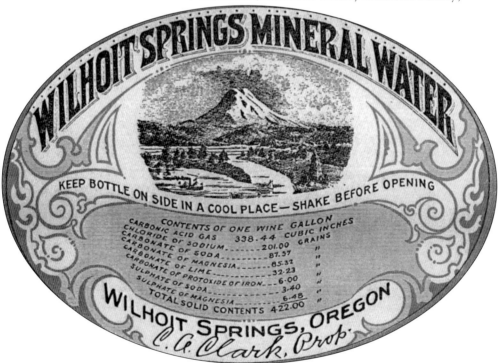

C. A. Clark served as manager of Wilhoit Springs in the 1920s, when this label was used on bottles of the famous water, which had been sold in Portland and other areas as early as 1872. An advertisement in the *Daily Oregonian* lists Thomas and Morgan as distributors of the "celebrated mineral waters" at the corner of First and Madison Streets. (MAHS.)

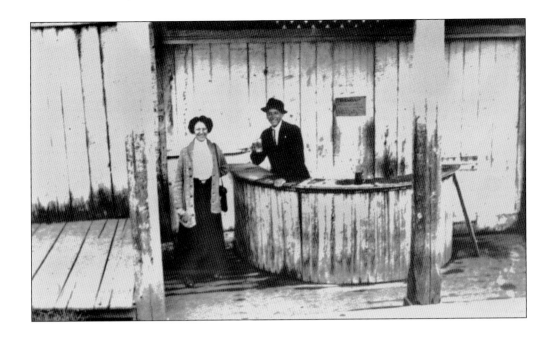

Naturally carbonated soda water was the main attraction at Wilhoit Springs. This couple (above) enjoys a glass of the renowned water in front of the spring or pump house. All sorts of health claims were made—from indigestion and skin diseases to nervousness and liver disease. The automobile stage (below) carried passengers to and from the hotel and Molalla, Mount Angel, and Woodburn, where the trains had depots. No tracks were ever built to Wilhoit. (Above MAHS; below Dianne Jeli.)

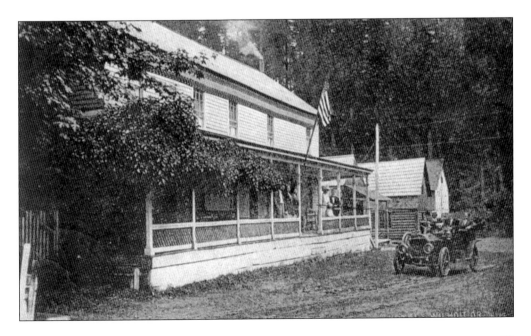

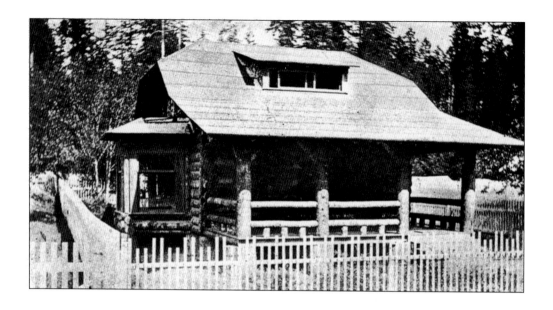

Frank W. McLeran's log bungalow (above) stood on the grounds of the resort near the entrance. The natural springs and wonderful woodland setting earned McLeran a nice living. An analysis of the water (below) shows just what all those people were drinking and bathing in through the years. Claims that the water could cure a craving for alcohol may have been exaggerated, but many who suffered hangovers drank the water to wash away its effects. The magnesium acted as a laxative if one ingested too much water. (Wilhoit Springs Association Papers, Box 027, Special Collections and University Archives, University of Oregon Libraries, Eugene, Oregon.)

THE WATER

Wilhoit water shows the following analysis:

One wine gallon of Wilhoit Mineral Water contains—

Carbonic Acid Gas, cubic inches	338.44
Chloride of Sodium, grains,	201.00
Carbonate of Soda, grains	87.57
Carbonate of Magnesia, grains	85.32
Carbonate of Lime, grains	32.23
Carbonate of Protoxide of Iron, grains	6.00
Sulphate of Soda, grains	3.40
Sulphate of Magnesia, grains	6.45
Total solid contents, grains	422.00

Bottled Water, f. o. b. Portland or Oregon City, per case of 50 quart bottles, $6.50; per case of 50 pint bottles, $4.50; per case of 50 half-pint bottles, $3.50. Salts, plain, per lb. 50c; effervescent, per bottle, 50c, or $4.25 per dozen bottles.

RELIEVES THE APPETITE FOR DRINK

It is the much appreciated experience of many drinking men that this water will satisfy the craving for strong drink in a most remarkable manner. The victim of drink finds Wilhoit Water a most refreshing, enlivening and invigorating draught which leaves no sting behind and no distressing reaction. It leaves the system in a splendid condition both physically and mentally. For that peculiar nervousness after a period of excessive drinking, the water used freely is admirable in its effect to soothe and quiet body and mind.

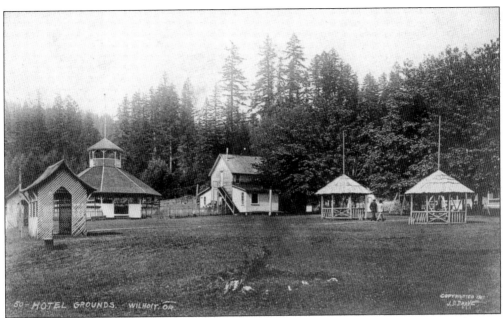

Various attractive gazebos and other shady structures with benches (above) allowed the tired visitor a place to sit quietly or visit with friends and take in the calming atmosphere at Wilhoit Springs. At the pyramidal-roof springhouse (below) in 1909, a lively crowd finds the accommodations inviting. The resort offered a number of delightful places to meet and visit, play cards, stroll, and enjoy the waters as a beverage or a soak. Many families spent a week or a month at the springs. Here they could enjoy rustic log and vernacular wood-frame architecture blended with a wooded setting. (Above Maria Vaughan; below Clackamas County Historical Society.)

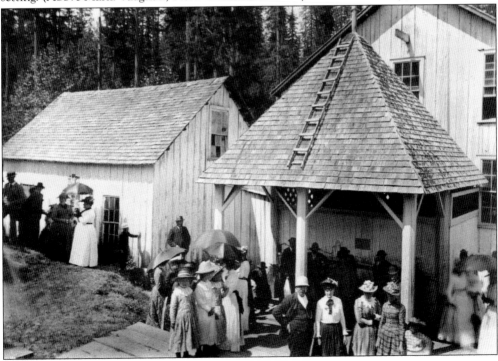

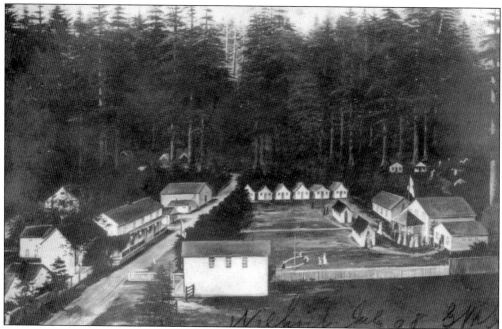

This artist's vision of Wilhoit was created in 1908, when F. W. McLeran owned the property. The resort's vast array of buildings included the hotel, bathhouse, swimming pool, bowling alley, dance hall, and pump house. A merry-go-round was installed for the youngsters. Cottages were placed here and there, while tents were erected in the woods. (Dianne Jeli.)

Wilhoit Springs Hotel

WILHOIT,
Clackamas Co., Ore.

F. W. McLERAN,
Manager.

Good Accomodation and Attendance
Table supplied with the Best the Market affords

Price of Board and Room $10.00 per week
,, ,, ,, without Room 7.00 ,, ,,
,, ,, ,, by the day 2.00
Children under 12 years, half price

Mineral Water Baths 25c. Sweat-outs 50 Cts., 3 for $1.00
OVER Stables in connection for Horses and Carriages

This business card lists the room rates and other charges for services at Wilhoit Springs resort. McLeran tried to ensure every possible luxury for his guests. He even had a stable for his visitors' horses and buggies and was responsible for building a road to the springs. (Wilhoit Springs Association Papers, Box 027, Special Collections and University Archives, University of Oregon Libraries, Eugene, Oregon.)

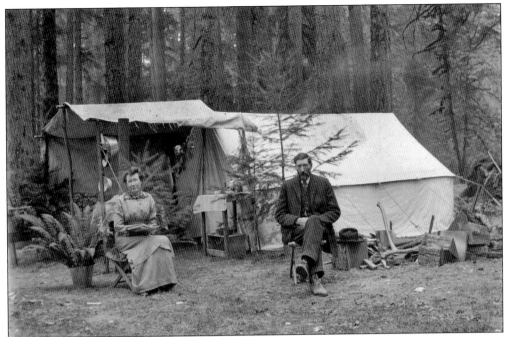

Tenting was popular at Wilhoit, with the store wisely offering all manner of camping equipment and supplies for just that purpose. Men and women brought along their finest clothing so they could mix with hotel guests and dine in the hotel when they wished. The woman in the photograph is Ella Pruett. (Maria Vaughan.)

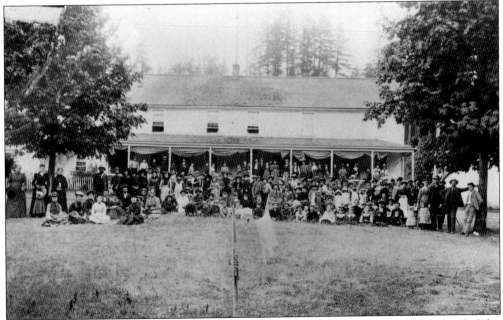

On July 4, 1890, guests gather on the veranda of the Wilhoit Hotel, which is draped in holiday bunting. In the foreground is a fireworks device attached to a stake. Bands sometimes played at the springs, and dances were held in the big pavilion. Local people often came to Wilhoit for these events. (Clackamas County Historical Society.)

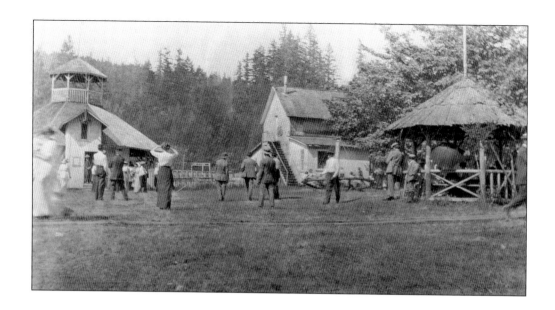

Wilhoit's rustic buildings (above) of the early 1920s included the band pavilion (left), the clubhouse (center), and the gazebo. Many of the log structures were built from trees cut at the resort site, no doubt making room for even more tents. People strolled the grounds, played cards, visited, and even fished and hunted nearby. Admission to the grounds was 25¢ at the entrance, but some locals used a trail from Ray Wylands's home and down over the hill to sneak in and avoid the charge. The admission price allowed the visitor all the spring water he cared for at no additional cost. This 1908 postcard of the springhouse gazebo (below) was a promotional view by June Drake, a Silverton photographer. (Above Katherine Johnson Oblack; below Maria Vaughan.)

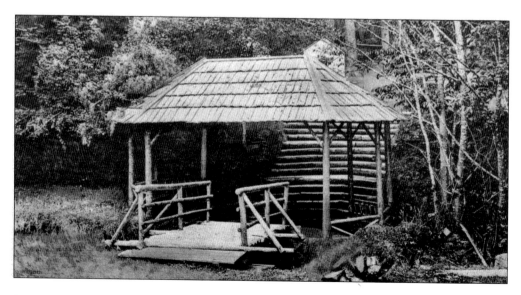

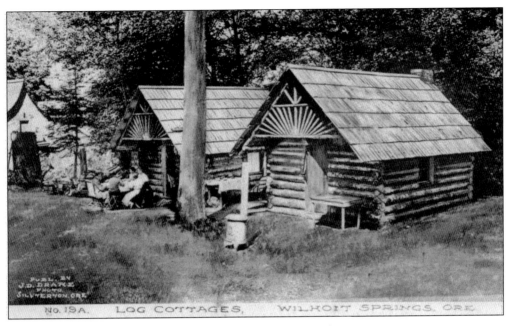

The log cottages at Wilhoit (above) had architectural detailing similar to log cabins on Mount Hood during the same period. Built to resemble small hunting lodges in Germany, they were a welcome sight to tired businessmen from the big city of Portland. A fellow could rough it without being too far from the amenities of the fine hotel. At left is one of the frame cabins with bellcast roofs. People staying in the cabins had the option to dine at the Wilhoit hotel, whose menu (below) offered delights found only in the finer establishments of the time. Oysters and halibut were exotic during an era characterized by slow travel from the coast and primitive refrigeration. To supplement the menu, locals caught trout in the nearby streams and sold the fish to the hotel. (Above Dianne Jeli; below MAHS.)

Wilhoit Hotel's Bill of Fare Tempting

(This Menu courtesy Mrs. Mae Schoenborn) **Wilhoit Springs Hotel** F. W. McLERAN, Proprietor WILHOIT, OREGON

A LA CARTE

Bill of Fare

APPETIZERS

Caviar on Ice..............25c Imported Sardines on Toast.30c
Anchovies in Oil..........25c Domestic Sardines in Oil...20c
Bismark Herring..........25c

RELISHES

Celery10c Dill Pickles 5c
Radishes 5c Sweet Pickles 5c
Queen Olives............10c Gerkins 5c
Stuffed Olives............10c Mixed Pickles 5c
Chow Chow 5c

OYSTERS

Cove Stew25c Shoalwater Bay35c

FISH

Boiled Norway Mackerel, Drawn Butter....25c
Fried Sound Halibut......................25c
Fried Columbia River Salmon.............25c
Tenderloin of Sole, Tartar Sauce..........25c

SOUP

Clam Broth10c
Bouillon10c
Cream of Tomato10c

EGGS AND OMLETTES

Eggs, Boiled (3)..........25c Omelette with Parsley.....25c
Eggs, Fried (3)............25c Omelette Plain...........25c
Eggs, Poached on, Toast (3).30c Omelette with Chicken Liv-
Eggs, Poached with Bacon..25c ers40c
Eggs, Poached Vienna Style.30c Omelette with Spanish.....30c
Eggs, shirred (3)..........25c Omelette with Jelly........30c
Eggs, Scrambled (3).......25c Omelette with Cheese......30c
Eggs, Scrambled with Ba- Omelette with Mushrooms..35c
con25c Omelette, French35c
Eggs, Scrambled with Truf- Omelette with Asparagus
fles40c Tips40c

VEGETABLES

Potatoes, French Fried.....10c Potatoes, O'Brien25c
Potatoes, Hash Brown......10c Stewed Corn10c
Potatoes, Lyonnaise........15c Stewed Tomatoes10c
Potatoes, German Fried....10c Stewed Mushrooms25c
Potatoes, Saratoga.........15c Stewed String Beans10c
Potatoes, Jullien..........10c Stewed French Peas15c
Potatoes, Stewed in Cream.15c Stewed French String Beans.20c
Potatoes, au Gratin........15c Boiled Rice10c
Boiled Cauliflower.........15c

CHEESE

Oregon Cream10c Edam10c
Imported Swiss15c American Cheese10c

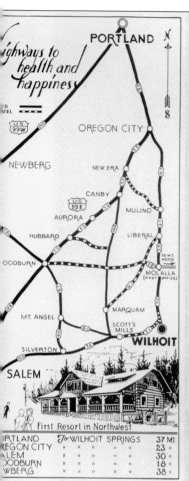

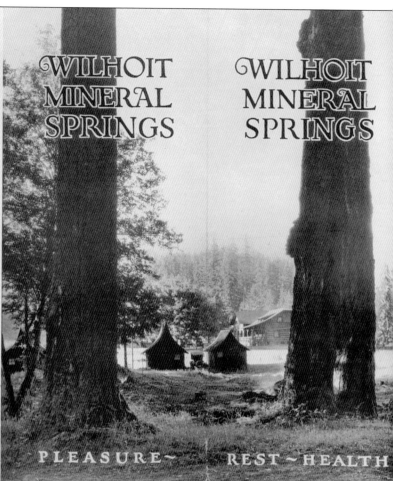

This promotional brochure shows towering fir trees and two of the rustic cabins south of the hotel and main grounds. The peaceful setting, far from big cities and dusty farms, was probably as much of a cure as the highly advertised mineral water. The hotel always offered "the best the market affords" and employed local labor. There were also indoor mineral baths, mud baths, and sweats. The management brought in entertainment and provided many restful places for people to stop and contemplate their lush surroundings. Silverton photographer June Drake captured images of guests and the resort that were made into postcards for sale. Many survive today to illustrate just how wonderful the experience was for the weary that sojourned there. (Wilhoit Springs Association Papers, Box 027, Special Collections and University Archives, University of Oregon Libraries, Eugene, Oregon.)

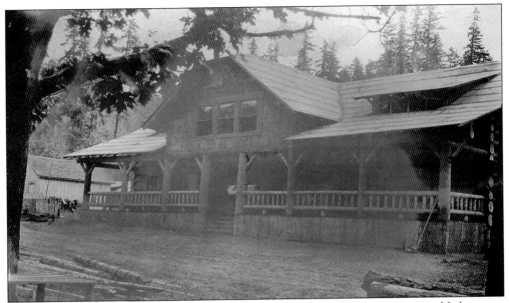

Frank W. McLeran's log hotel, seen prior to 1916, incorporated logs that were most likely cut on the property. The long veranda would have been a lovely place to sit and while away the hours, enjoying the clean air and quiet. The second hotel on the property, it sadly burned in the 1920s. The first hotel had also been destroyed by fire. (Dianne Jeli.)

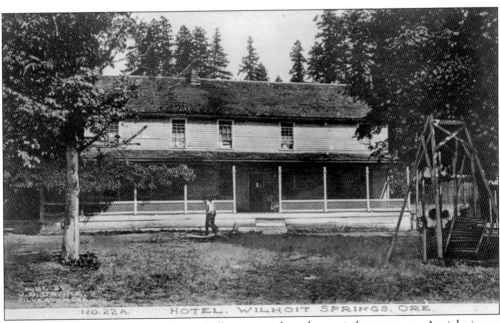

The wood-frame hotel was the first at Wilhoit, preceding the rustic log structure. At right is one of the well-known glider swings that were rebuilt over the years and lasted into the 1950s. During the 1950s, the Wilhoit grounds were owned by Albert and Mae Schoenborn. (Dianne Jeli.)

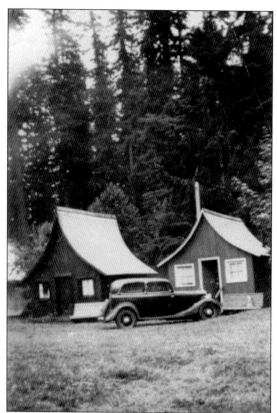

In 1930, these one-room cottages with quaint bellcast roofs were considered cozy accommodations in the peaceful surroundings at Wilhoit. Resembling an early motor inn, each was furnished with a bed frame, table, and chair. People who did not wish to stay in the hotel or camp with a tent took advantage of these cabins. Meals could be taken at the hotel. (Clackamas County Historical Society.)

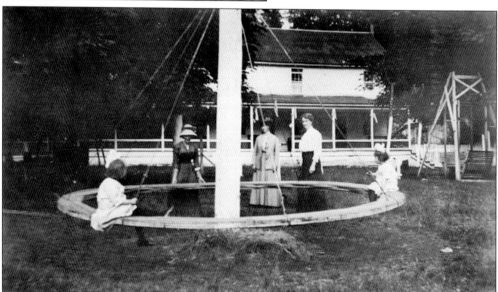

Children visiting the resort were entertained with swings, a primitive merry-go-round, and the games they invented themselves. The grounds provided ample room for running and playing ball and the shallow Rock Creek for wading. There were also wooded trails to explore and trees to climb. (Wilhoit Springs Association Papers, Box 027, Special Collections and University Archives, University of Oregon Libraries, Eugene, Oregon.)

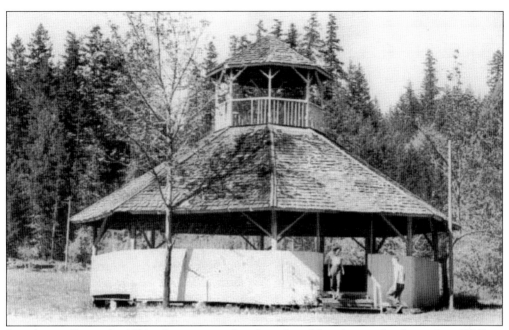

Standing well into the 1950s, the enormous band pavilion (above) was a familiar sight at Wilhoit Springs. This photograph was taken in 1954, long past the heyday of the resort. People still came for the water, many taking it home in their own bottles and jugs, but no one was camping or staying in the cottages by then. The craze for mineral cures was over for the time being. No new hotel had been built to replace the burned structure. Only three cottages still stood, in a lonely row back against the trees (below). One account says the cottages were built by Chinese laborers on Sawtell's teasel farm and later moved to the Wilhoit Springs grounds, but this story is unconfirmed. (Above Ben Maxwell Collection, Salem Public Library 3830; below 3841.)

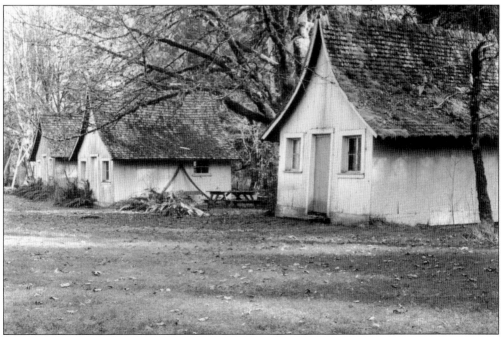

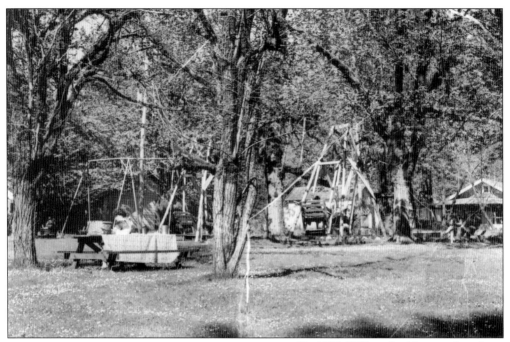

By 1954, Wilhoit had been reduced to a pleasant place for a picnic or a quick drink at the spring. The swings (above) were still in use, the picnic tables kept in repair, and the pump working. A few minutes with the old pitcher pump would fill as many bottles as a person wanted. Some patrons swore by the soda water for making light and fluffy pancakes. Others used it for stomach problems. A good many just liked the acquired taste. By now, most visitors were locals or people who had been raised in the area but had moved away. The cottage (left) stood with the door permanently ajar, expecting no one, in 1956. (Above Ben Maxwell Collection, Salem Public Library 3828; below 3836.)

Seven

BOOKS, BIBLES, AND BROTHERHOOD

Soon after the first settlers completed their cabins on the Molalla Prairie, more wagon trains arrived with additional families. Since they desired some of the same structure and social life they remembered from back home, the new citizens soon built a log schoolhouse and later a frame school. It was not until 1906 that high school classes were offered. Many small, one-room schools sprang up in the surrounding areas for the children whose families lived too far from Molalla to walk or ride a horse to school. Eventually most of them merged with Molalla or simply ceased to exist.

Molalla schools have a long history of celebrating May Day with the winding of the Maypole and the choosing of a May Queen and court. Athletics and team sports were established early for the girls and boys. Molalla also fielded a few community baseball teams over the decades.

The first organized religious activity in Molalla was initiated on October 19, 1848, by the Primitive Baptists, who met in members' homes.

The first church built at Molalla was in 1869, but Methodist meetings were held in the log school as early as 1854. The Church of Christ established a presence in Molalla in 1863, and the Seventh Day Adventist Church arrived in 1921. Catholics started holding services in 1920 but did not establish a parish until St. Williams (now St. James) in 1938. In the 1930s, a Mennonite Church offered services, but the congregation lost the bulk of its membership when the Emmert brothers moved to the Sweet Home area. The Christian Church split off from the Church of Christ and took over the former Mennonite building. Other churches were established in later years.

In 1902, Grange No. 310 was organized by the Patrons of Husbandry with 122 charter members. Dr. J. W. Thomas, Molalla's first dentist, was its initial leader. Other fraternal organizations followed. The Masons, Odd Fellows, and Eagles Lodges settled in with many second- and third-generation members. The Eagles purchased the old Band Hall, which was used as a lodge hall, band and dance space, and roller-skating rink before it was sold to the Seventh Day Adventist Church. The congregation later used lumber from the demolished Band Hall in their buildings north of town.

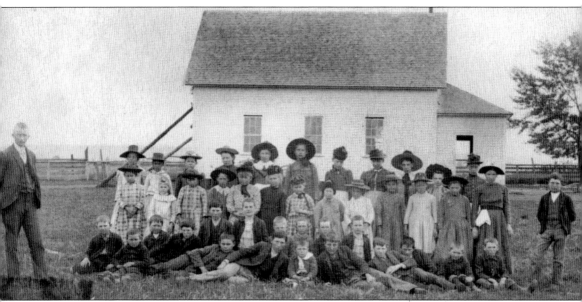

In 1875, Molalla's second schoolhouse was located east of town on what is now the Coleman Ranch along State Highway 211. The site was originally the Asa Sanders land claim. No known photograph exists of the first schoolhouse, which was built of logs. The pictured frame building was 21 by 31 feet and 12 feet high, with the door in the center of the south wall. Teacher J. L. Ogle earned $70 in July 1875 and received another $30 in October of that year. Some of this money came from the state fund and most from the county fund, with locals paying the remainder. (MAHS.)

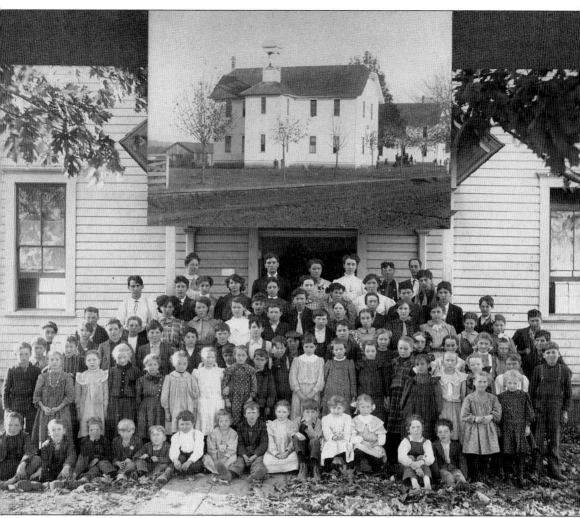

Centennial School, built in 1895 on East Main Street, was later moved slightly west to make room for the next new school. It was used as a grade school and then as an overflow or gymnasium building when the other school was built. This two-story school had only four rooms. A 9th-grade class was offered in 1906, a 10th-grade class in 1910, and 11th- and 12th-grade classes in 1912. The structure shown here in the 1906–1907 school year was torn down about 1923–1924, and the resulting lumber went into building new homes. Some of the names of students in this photograph are Johny Echard, Marjorie Gregory, Marion Toliver, Reva Everhart, Lee Looney, Vivian Robbins, Oliver Buxton, Agnes Clifford, Hugh Cutting, Nina Dunton, Zella Adams, Carl Feyer, and Vida Cole. Members of the Ridings, Hungates, Ramsby, Vick, Engle, Powell, Shaver, and Harless families are here too. Reva Case served as the teacher. A nearly complete list of those pictured is available at the Molalla Area Historical Society. (MAHS.)

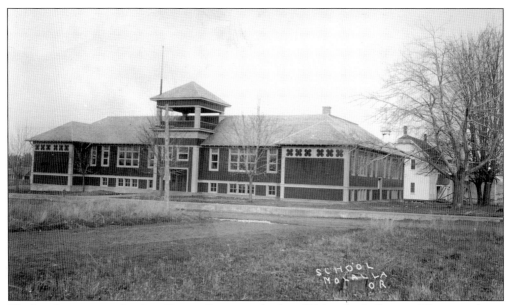

The handsome new school on Grange Street was built in 1914 with a bell tower. This view shows the old Centennial School in the background. The new, modern building, much larger to reflect the growing community, became a combination elementary and high school. The 1914 school was demolished in 1957 to make way for a small shopping complex. (Dianne Jeli.)

The Molalla girls' basketball team from 1915 may have been the first girls' team. It featured the following players, from left to right: (first row) Elsie Dart, Zella Shaver, and Glean Dunton; (second row) Zelma Fredericks, Goldie Harless, and Naomi Robbins. The coach was Robert Rose. Girls' basketball uniforms of the day were modest and cumbersome, as evidenced by the neck scarves. (Carl Cline.)

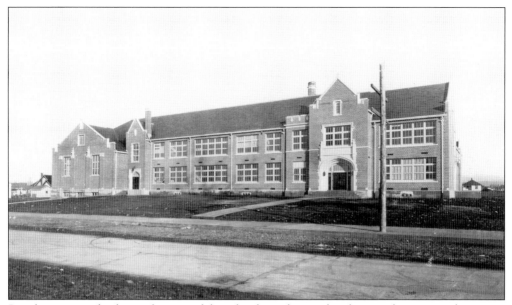

Population growth, the unification of the schools, and an updated curriculum meant that a new high school was in order—this time a large, permanent structure. The new high school, located on South Molalla Avenue, was planned by the school board in 1923 and completed in 1926. The specifications were drawn up by Portland architect Raymond W. Hatch. The Renaissance architectural design was often applied to educational institutions. (MAHS.)

Now serving as the middle school, Molalla's new brick elementary school was built west of town on Leroy Street in 1950. Someone suggested that the frame structure with brick veneer looked like a chicken coop, since the long, single-story building was bedecked with so many windows. Working on the project were architectural firm Freeman, Hayslip, and Tuft and contractor C. F. Johnson. (Oregon Historical Society Photograph #005905.)

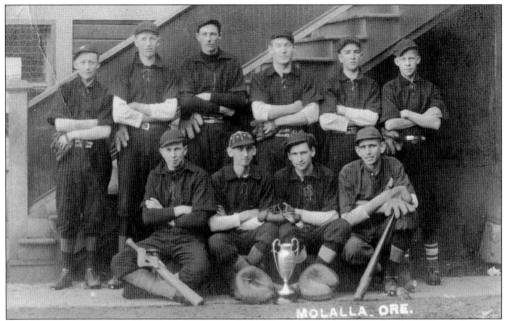

The boys' baseball team *c.* 1920 at the Molalla School are, from left to right, (first row) Ross Engle, Duane Robbins, Asa Kellis, and Leonard Vick; (second row) Earl Berdine, Ernest Palfrey, Lester Tibbs, Joseph Olesen, Guy Hatton, and Einar Jackson. The boys had just won a trophy when they posed for this photograph. Many people enjoyed attending the games against Estacada, Scotts Mills, and other regional schools. (Judy Gregory Kromer.)

The 1921 boy's championship high school basketball team consisted of the following, from left to right: (first row) Harold Ridings, Alvin Glutsch, and Harold Jackson; (second row) Chet Granquist, Ray Heiple, Dick Palfrey, and manager Walter Taylor. The state basketball tournament was held in Salem, and Harold Ridings was selected as one of the state's all-star players. (MAHS.)

On March 25, 1993, the 1926 brick Molalla High School was severely damaged in a 5.7-magnitude earthquake centered at nearby Scotts Mills. At the time, the building was being used as a junior high school. Many people in the community hoped the school would be repaired, but it was eventually demolished and the grounds became a city park. The public library was moved to an undamaged portion previously housing the high school library. Several architectural elements from the historic building, which had been listed in the National Register of Historic Places, were preserved in the construction of the Ivor Davies Hall at the Molalla Area Historical Society complex near the Dibble House. Some of the bricks were used as walkways on the museum grounds. The newest high school building, a remodel of a 1970s structure, is situated in the northern end of town. (MAHS.)

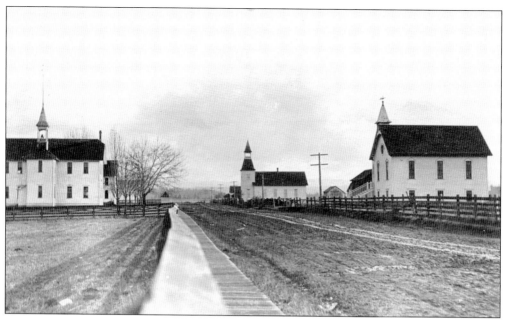

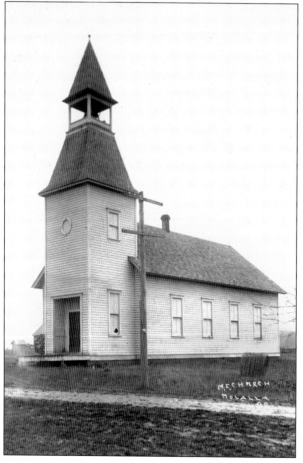

The eastward view of Molalla's Main Street (above) shows, from left to right, the Centennial Grade School, the Grange Hall behind it, the Church of Christ, and the Methodist church. The top board of a fence runs like a ribbon along the board sidewalk. The Church of Christ congregation built its church (left) about 1909. The original structure is now a boot and saddle repair shop, and today the church is situated in the 1967 building on Fenton Street. The Church of Christ started south of town on the Charles Dart farm in 1863. Dart was one of the founders of the congregation, which first met in a member's home. A meetinghouse was constructed in 1898 on the Dart farm. (Above Carl Cline; left MAHS.)

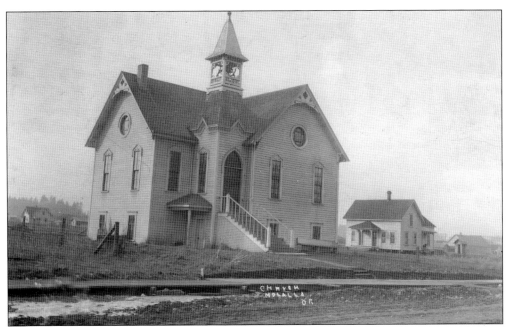

The Methodist church on East Main Street (above) was the third structure the Methodists built in the community, erected in 1905–1906. The second was north of town on the Sanders property, marked by a small cemetery. The first worship center was south of town at the corner of Wilhoit and Herman Roads. The congregation met in the old log schoolhouse in 1854, with Methodist missionary Jason Lee riding by horseback from the Salem area to lead services. The interior of the 1905–1906 Methodist church (below) reveals one of the old pews retained in the newest Methodist church, built at the east edge of town. The older church still stands. (Above Odeane Thelander; below Molalla Methodist Church.)

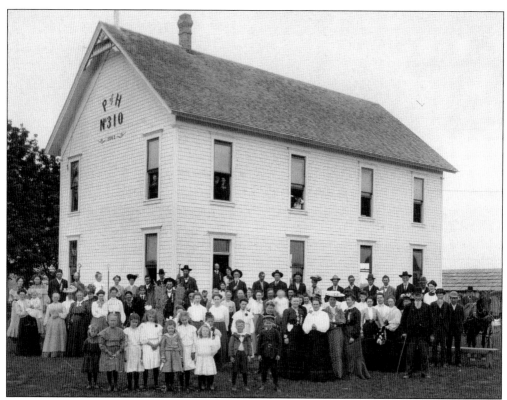

Molalla Grange No. 310, the Patrons of Husbandry, was established in 1902. The first hall, pictured above, was completed in 1903. Among Grange activities was the annual community fair (below) that had been held since the earliest days of the organization. An earlier fair had occurred east of Molalla on the 600-acre Oliver Robbins farm. When the new Grange Hall was built in 1966, the former two-story building was left standing. The new building encompassed a former World War II community cannery, where citizens had brought their own garden produce and sealed it in tins for a small fee. This cannery room became the kitchen for the new hall. (MAHS.)

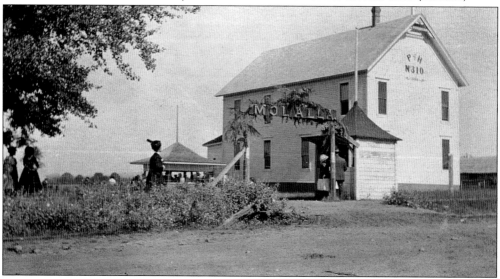

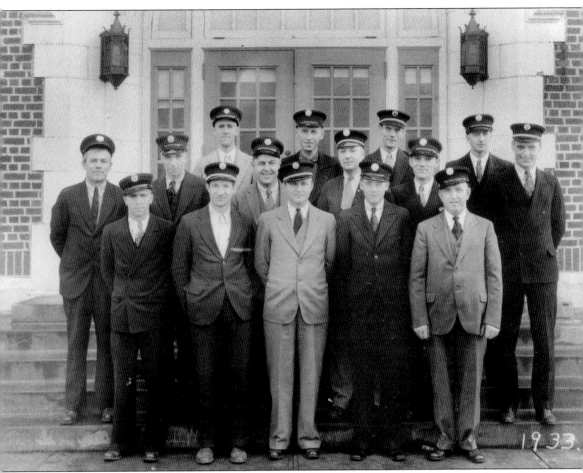

The Molalla Volunteer Fire Department, shown on the steps of the new high school in 1933, included the following, from left to right: (first row) Secretary Howard Slyter, Junior Capt. George Emmert, Chief E. R. Wallace, Donald Larson, and Jack Peterkin; (second row) Hose Foreman James Waller, Frank Slyter, John Stoars, C. W. Kendall, Mitchell Slyter, and Senior Capt. Norman Granquist; (third row) Ben Lindland, E. E. Turner, Assistant Chief Chester Granquist, and Oswald "Ossie" Marson. Rufus Kauffman is not pictured. The men are posing in their business suits and firemen's caps. Two members of the Emmert family volunteer with the Molalla Fire Department today. The department began service in the early 1900s with a hose cart pulled by hand. (Oregon Historical Society Photograph No. CN005904.)

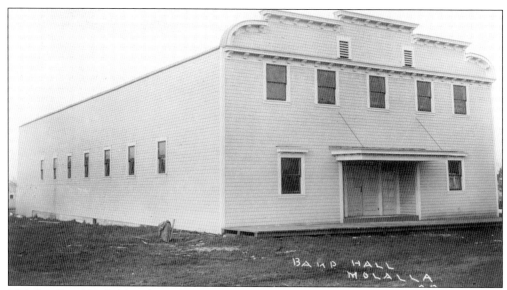

Molalla's Band Hall (above) was built on Engle Avenue in 1914, but the town's brass band had actually organized in 1888, with the first public performance held at a political meeting. Members in 1888 were Dr. John W. Thomas, F. H. Dungan, J. V. Harless, William Mackrell, Fred Kendall, Thomas G. Husbands, Walter Dibble, Frank Adams, J. M. Austin, George Adams, Morris Myers, Xavier Myers, and Wayne Robbins. John S. Dungan was elected instructor. Pictured below in 1923 are the following, from left to right: (first row) Fred Bruce, Herman Chindgren, Eskil Renhard, Don Bauer, Burrel Cole, Jack Cole, Oscar Franklin, Willis Dunton, Earl Nauertz, Ed Eyman, and Alvin Perdue; (second row) George Blatchford, Charles Kent, Dr. E. R. Todd, Walter Taylor, Ben Chindgren, Bill Mackrell, I. F. Bradley, Les Little, Paul Robbins, Harry Harvey, and Roscoe "Rocky" Hibbard. (Above Dianne Jeli; below MAHS.)

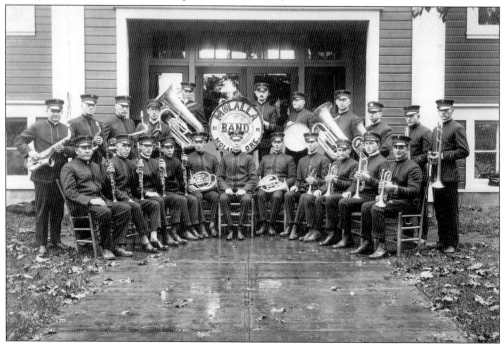

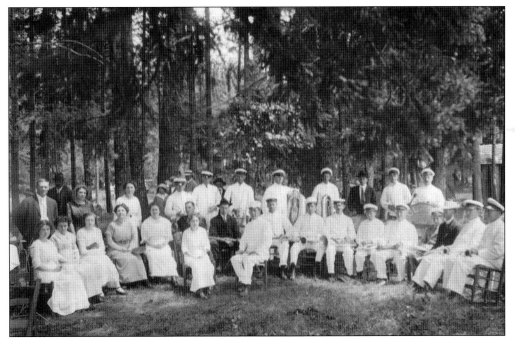

Popular at Fourth of July gatherings, Molalla's brass band members are shown here in their white uniforms. For a small town group, they were well equipped and quite well known throughout western Oregon. In 1922, the band played at the Dallas Round-Up south of Salem. It was one of only a few bands in the Willamette Valley at the time. (MAHS.)

The Odd Fellows Hall was built near the northeast corner of Main Street and Molalla Avenue between 1915 and 1921. The lodge had received its charter in 1905 but continued to meet in the local Grange Hall. The entire Odd Fellows building was destroyed by a fire in 1944 that also burned the Dicken and Company grocery store on the ground floor, the wartime ration board office, and the only drugstore in town. (Marie Wells.)

The Molalla Stars baseball team was a community club that played locally. Players of 1915 included the following, from left to right: (first row) Guy Schaefer, Brick Schamel, Cis Grimm, Hoke Moody, and Bill Reynolds; (second row) Grover Fredrick, an unidentified man hired to pitch, Leonard Vick, and Leo Shaver. No substitutes meant that each player had to play the length of every game. (MAHS.)

Dudley Carson Boyles (center, with dark hat) and W. W. Everhart (with bibbed overalls) engage in a hunting expedition with horses outside Molalla in the early 1900s. Hunting in those days required many days camping out and some time to travel back home with the bounty. It was often a group effort. (MAHS.)

Eight

LUMBER IS KING

Molalla had depended almost entirely on raw timber to support the local economy and keep it strong, but today the nature of the industry has changed dramatically in response to environmental concerns. Molalla started with pioneer lumber mills, which were usually temporary or portable mills that supplied the needs of settlers. Early mills in the area were John Cutting's sawmill on Milk Creek at present-day Route 211, Richard Howard's 1848 sawmill at present-day Mulino, Maxwell Ramsby's sawmill on the Molalla River near the current intersection of Wright Road and Route 211, and the 1854 Trullinger sawmill at Union Mills. These mills were successful partially in response to the 1849 California gold discovery. Demands for goods revitalized Oregon's economy and created a large and profitable lumber export business.

In the early 1900s, timber was harvested from river drainages in the Clackamas County slopes. Commercial-scale sawmills were built in profusion in response to lumber demands. The timber industry in Oregon had leapt by 1920, and at least 20 sawmills were located in the vicinity of Molalla, cutting all the timber within easy reach. In 1914, E. S. Collins purchased a tract of Molalla timber (37,320 acres) and then developed it as a successful operation in 1939 under the Ostrander Railway and Timber Company name. Large stands of timber remained in the mountains, waiting for larger commercial establishments. In 1924, the Eastern and Western Lumber Company moved into the mountainous section southeast of Molalla, securing a 20-year supply of timber, and set up logging camps along a railroad the firm built 20 miles south of Molalla. About 70 men lived in each camp. The lumber was transferred at Molalla to the Willamette Valley Southern Railroad and shipped into Portland. The company's first load in 1927 marked the beginning of a new lumber industry in Molalla. Most of the prime lumber used by area sawmills came from the abundant fir, cedar, and hemlock forests that were east and southeast of Molalla in the foothills of the Cascade Mountains.

By the 1940s, lumber had become king, and Molalla's sawmills were operating day and night. The Ostrander Company joined forces with the Weyerhaeuser Timber Company to build the Canby-Molalla logging road for heavy truck use in 1943. Crown Zellerbach bought out Ostrander and, alongside Weyerhaeuser and Pope and Talbot, became one of the largest timber companies in the area. Meanwhile, many smaller local sawmills and gyppo logging outfits continued to operate at the same time. The best-known and largest lumber mills in town were the two Avison Mills, the A. F. Lowes Lumber Company mill, and the Kappler Mill at Liberal.

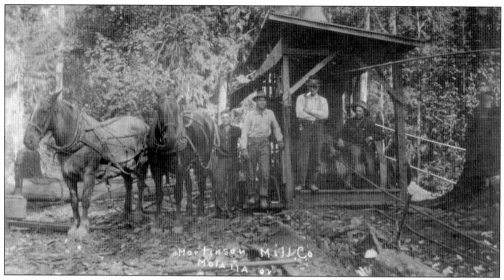

Ferd Mortenson was logging with horses and a steam donkey in the early 1900s. Pictured above from left to right are Earl Davidson, Frank Lay, Abe Russell, and Louis Bergstrom. Mortenson owned sawmills along Teasel Creek and Herman Road. The town was growing, and the demand for lumber was great, but the mills also sold lumber to bigger markets. The coming of the railroad facilitated the shipping of large quantities from the several community sawmills to major outlets. The change in product is noted in the advertisement below for molding and kiln-dried and dressed lumber. Ferdinand C. Mortenson was born in 1898 and died in 1964. (Above MAHS; below *Molalla Pioneer*.)

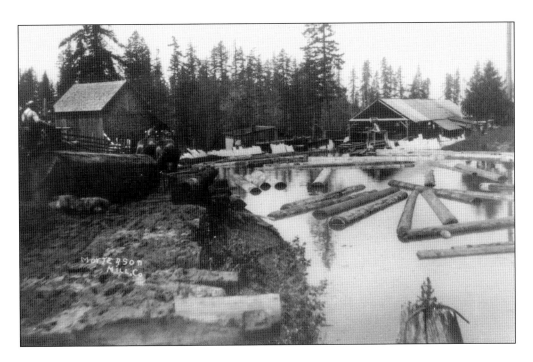

The above photograph of a Mortenson sawmill, possibly along Teasel Creek, shows the ponds that were dug and used to float the logs closer to the headrig of the mill. The water also kept the wood from drying. Above, draft horses are yarding a huge log to the pond. Horses and oxen were used extensively before mechanized yarding equipment was invented. This mill was built close to a source of timber, thus eliminating the need to transport logs over a great distance. Below are seen a stack of lumber and stacks of cordwood for feeding the firebox of the steam engine that ran the sawmill. The shacks in the background may have provided housing for loggers or mill workers. (Above MAHS; below Marilyn Sawtell Behrends.)

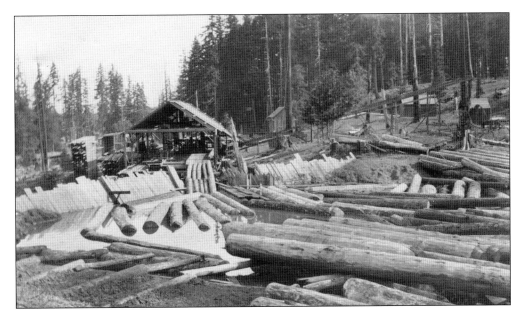

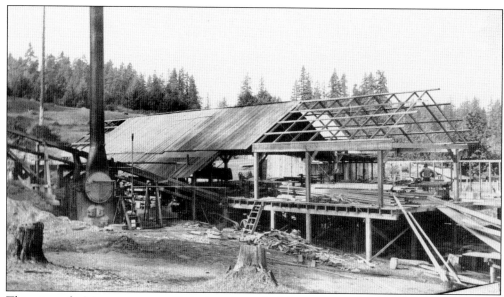

This view of a Mortenson sawmill depicts the end of the process, when the boards were sorted and stacked. In the days of abundant timber, inferior lumber was simply not fit to sell. Waste wood was burned to run the machinery or given away. Bark was peeled from the logs with a tool called a bark spud to prepare the logs before sawing. (Marilyn Sawtell Behrends.)

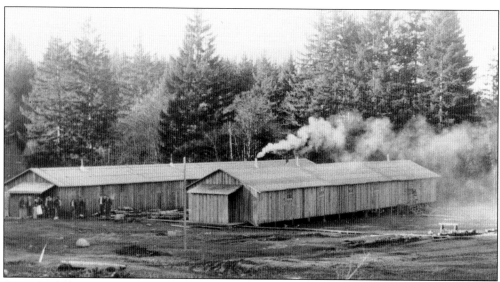

Camp Molalla, pictured in 1934, was a logging camp located 17 miles east in the woods outside of town. The men lived in bunkhouses and ate in a common dining hall. Weekends meant a trip to town for a special meal, perhaps a movie at the Lyric Theatre, and a chance to shop in the local stores and visit the taverns. (Oregon Historical Society Photograph No. 020062.)

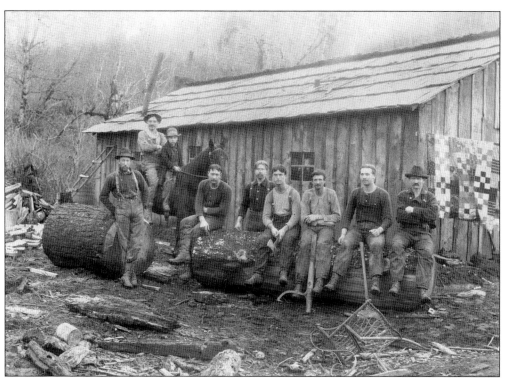

Peaveys and axes were at hand for this logging camp crew (above) at the Eastern and Western Lumber Company after 1926. Unfortunately the names of the men went unrecorded. The workers were able to journey into town on weekends in the speeder on the railroad tracks. Eastern and Western built a camp southeast of town in the Elk Prairie hills for men and their families called Family Camp (below). Clara Kolshinski taught here at the Eastern-Western School from 1931 to 1934. In the winter, most families moved to lower elevations, while those who stayed in camp used skis to fetch the mail miles away. The schoolhouse is the only remaining building from the camp and is now used as a home. (Cecil Werner.)

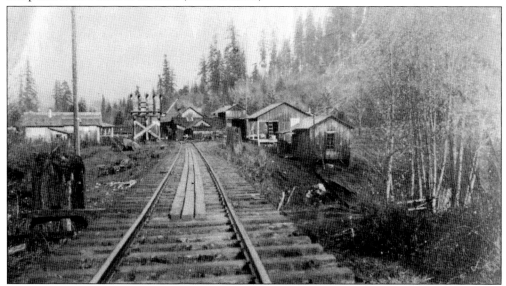

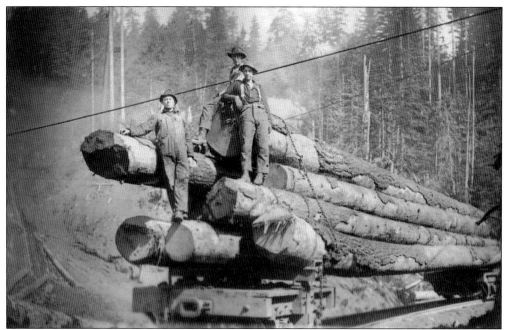

Bill Werner (left) stands on a load of logs in the above photograph, taken sometime after 1927. Flatcars were used by some logging railroads, but Eastern and Western used these skeleton cars. This contrivance probably saved money over buying flatcars. The lumber company shipped all its logs to the Willamette River from the vast land holdings near Molalla. When Eastern and Western ceased operations in the late 1930s, many of the railroad camp bunkhouses were taken to Molalla, set up west of town along Highway 211, and used as homes after remodeling. The largely unaltered unit below still stands. These bunkhouses were moved from place to place on rail cars and set in clearings along the tracks to house the builders of the railroad. (Above Cecil Werner; below Lois E. Ray.)

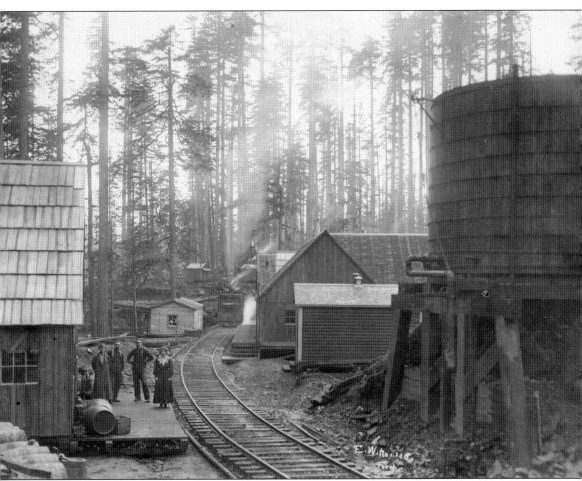

Family Camp was an Eastern and Western Lumber Company camp at Elk Prairie, shown here after 1927. The water tower for the engines and perhaps the camp looms over the people below. The camp had a commissary, mess hall, machine shop, and office. An engine sits in the background with its steam up. Logs from the hills were hauled to Molalla by Eastern and Western engines, then transferred to the Willamette Valley Southern tracks and pulled by that company's electric engines to log dumps. The old car barn, located west of town, was later used as a shop by Molalla Iron Works before burning in the 1960s. Eastern and Western suffered a devastating wildfire and the Great Depression. Much of the company's equipment was scrapped during and after World War II, including a Lidgerwood skidder and railroad engines. However, old-timers in Molalla still refer to the former timberlands as Eastern-Western, leaving out the "and." (Cecil Werner.)

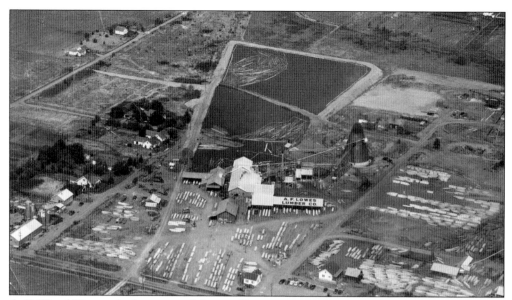

A. F. "Frank" Lowes built a successful sawmill operation on the west edge of Molalla, as shown in the 1948 aerial view above. He also owned a tavern on Main Street, Frank's Place, where he perhaps got back some of the money paid to his mill workers. The old railroad right-of-way became a mill road. The wigwam burner was used to burn bark and scrap wood almost around the clock. Lowes died when his new Packard collided with a log truck in 1952. The crew of 1948 included the following, pictured below from left to right: (first row) unidentified, Faye Huiras, Joe Hopfinger, Roscoe Reeves, unidentified, Ray Savage, and unidentified; (second row) unidentified, Buster Johnson, unidentified, Verdin "Curly" Hemphill, unidentified, Art Husbands, unidentified, Ed Russell, Joe Stiggens, and "Choppy" ?; (third row) Herbert Hillman, seven unidentified, Rocky Weigel, and Claude Yoder; (fourth row) ? Andrews, Cotton Poulson, Eli Walch, Elmer Cordill, unidentified, Jake Haynes, unidentified, Francis Shilts, and five unidentified. (Above Ralph Piuser; below Janine Kester.)

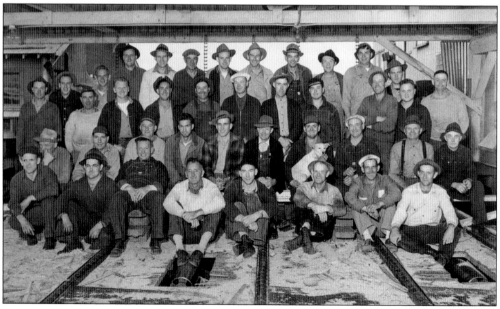

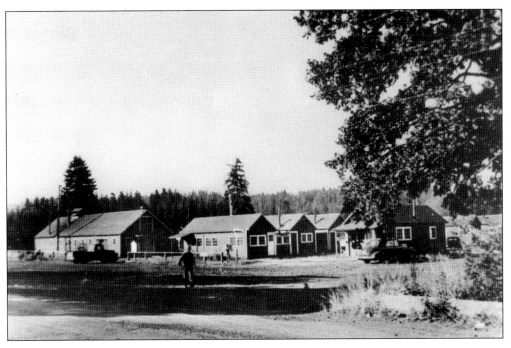

The 1939 Ostrander Company (above) logging camp was situated across the Molalla River, east of town in the Dickey Prairie area. The Collins family brought the company down from Ostrander, Washington, and logged where Eastern and Western had previously worked. The Ostrander camp had a cookhouse (left), bunkhouses, an office, and housing for supervisory staff. The photograph below may have been taken in 1946. Crown Zellerbach came to the area in 1945 and bought 44,468 acres of timber from Ostrander, also acquiring the camp. Ostrander built the Molalla Forest Road (the logging road) to haul logs where some of the former Eastern and Western Railroad right-of-way had been. Trucks and roads were now replacing all the logging railways. (Weyerhaeuser Company.)

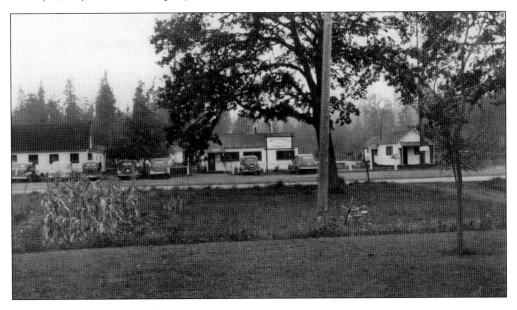

Crown Zellerbach's camp featured homes built in 1946 and shown in the above 1947 photograph, taken on Dickey Prairie. The houses remain today across the road from the current Weyerhaeuser office. From left to right, they belonged to cook Henry Hobson, forester R. M. King, office manager V. A. Connell, and company superintendent L. N. Rees. In the below photograph, is the new office built in 1951 by Crown Zellerbach, with the cookhouse at left and bunkhouses at right. Only the office still stands and is used by Weyerhaeuser. Behind the new office is the tower for the main radio station and the anemometer of the central weather station on the base of the flagpole. (Harold Brown photographs; Weyerhaeuser Company.)

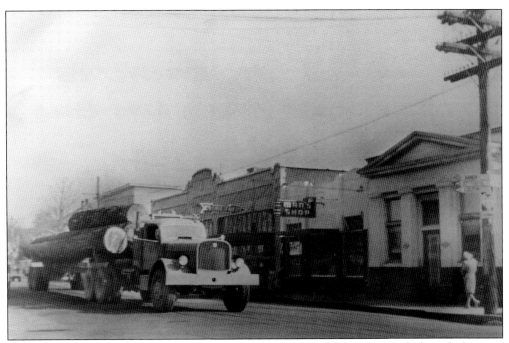

Prior to construction of the Molalla Forest Road, a truck with a load of logs wheels through the main intersection of Molalla in 1941. The logging road was built three years later, and the trucks used that route to reach the log dump near Canby on the Willamette River. (Weyerhaeuser Company.)

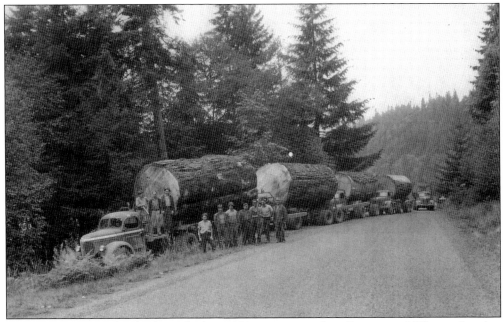

These now-rare one-log loads in the late 1930s were carried on Eastern and Western Lumber Company trucks. The first log was measured at about 13 feet in diameter. Good roads and large trucks quickly relegated the railways to the scrap heap. Ed Engle is the man in the middle, behind the cab of the truck. (MAHS.)

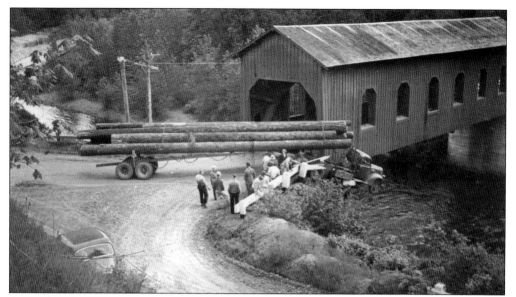

Around 1952, Dennis Bunke managed to hang the cab of his log truck over the river at the apron of the Dickey Prairie covered bridge. He escaped unharmed, and no logs were lost. The incident caused a crowd to gather since their passage across the bridge was blocked for some time. (Katherine Johnson Oblack.)

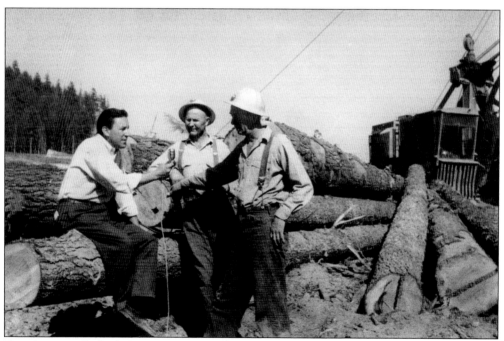

Two Crown Zellerbach loggers, Jack Tienhaara (center) and Eldon "Red" Barth (right), get up close and personal with future *60 Minutes* correspondent Mike Wallace (left) in 1960. Wallace was spending time in the area collecting stories for a radio and television program called *Close-Up USA*. Tienhaara was a world-champion high climber, and Barth was a hook tender. (Weyerhaeuser Company.)

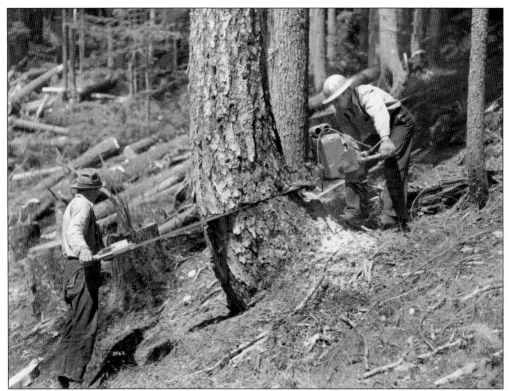

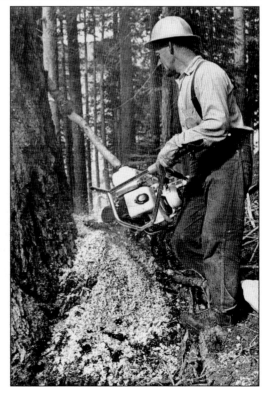

Above, Nolen Schoenborn (left) and an unidentified Crown Zellerbach felling partner saw logs in the Molalla woods during the late 1940s or early 1950s. They are using a two-man chainsaw, possibly a Disston. Timber fellers had to carry their own saws as well as oil for the chain, gas, wedges, and axes. They often negotiated very rough and steep terrain. Pictured right is Bill Fries, who felled trees with Nolen Schoenborn, John Chelson, and others. Unfortunately Fries died on the job in the woods. (Above Howard Heinz; right Linda Fries Fuellas.)

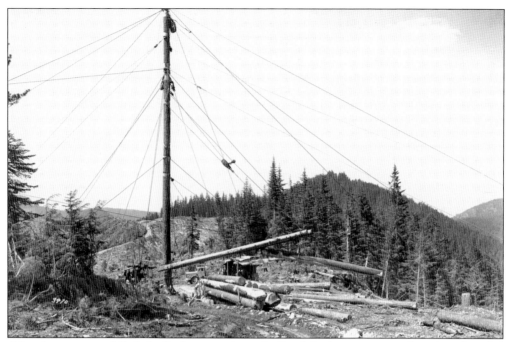

After the trees were felled, the limbs were trimmed off and the logs were cut to length and yarded to the landing for loading on the trucks. The spar tree was rigged with lots of lines and blocks to handle the logs. This spar tree also has a heel boom. The men working on the landing are likely the first and second loader and the chaser. (Howard Heinz.)

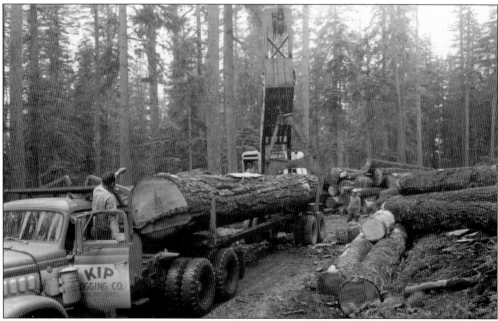

Gilbert "Kip" Kappler's Kip Logging Company was one of the largest locally owned operations in the area. He ran a logging company while his brother Ralph maintained a sawmill. Also an inventor of logging equipment, Kip built the Arrowhead Golf Club in the early 1960s. His brother started the Mulino Airport. (Jude Kappler Strader.)

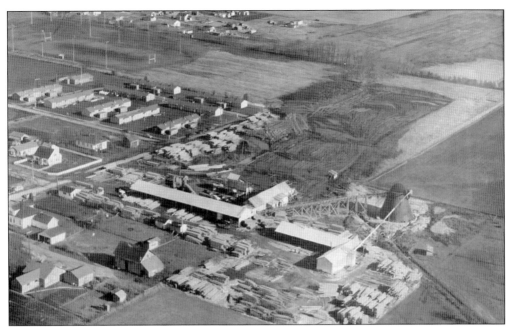

These aerial views of two Avison Lumber Company sawmills in Molalla reveal the Fir Mill, or Mill No. 1, above; and the planer and dry kiln at the Avison and Anderson Mill on Seventh Street and Hart Avenue below. The kilns at the center foreground below burned to the ground in July 1961. The 1950s photograph of the Fir Mill also shows the high school football field and the Timberland Homes triplex units, a nearby housing project. In the mid-1930s, William Avison started the Fir Mill in order to cut large logs. Avison joined with Lyle Anderson to form the Avison and Anderson Mills, later buying out Anderson's interest. In recent years, the third generation of the Avison family sold all of its mills but still has enterprises in the Molalla area. (Avison Group.)

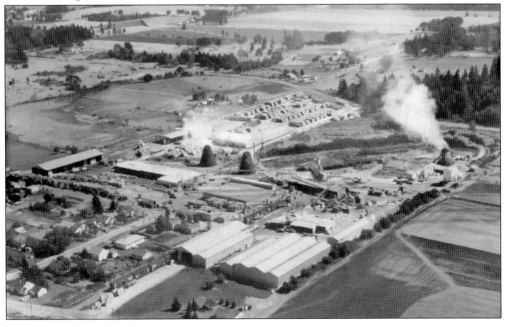

ACROSS AMERICA, PEOPLE ARE DISCOVERING SOMETHING WONDERFUL. *THEIR HERITAGE.*

Arcadia Publishing is the leading local history publisher in the United States. With more than 4,000 titles in print and hundreds of new titles released every year, Arcadia has extensive specialized experience chronicling the history of communities and celebrating America's hidden stories, bringing to life the people, places, and events from the past. To discover the history of other communities across the nation, please visit:

www.arcadiapublishing.com

Customized search tools allow you to find regional history books about the town where you grew up, the cities where your friends and family live, the town where your parents met, or even that retirement spot you've been dreaming about.